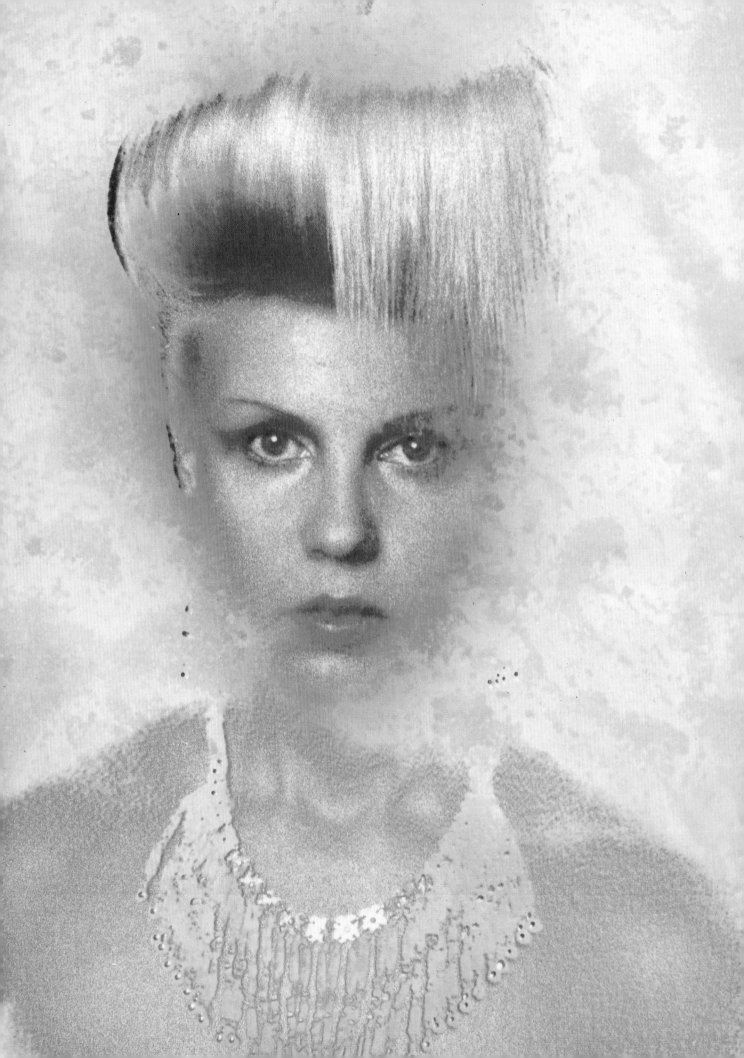

Experimental Photography

John Warren

Edited by
L.F. Robinson

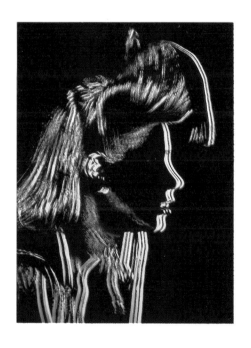

amphoto

This book is respectfully dedicated to the memory of my twin brother Peter who was killed in the Invader bomber crash during an Air Display at Biggin Hill on the 21st September, 1980 – he was taking photographs.

Fountain Press Ltd.
65 Victoria Street,
Windsor,
Berkshire SL4 1EH
England.

ISBN 0 86343 0422

© Fountain Press Ltd., 1984
Published October, 1984

AMPHOTO BOOKS
American Photographic Book Publishing
An imprint of Watson-Guptill Publications
1515 Broadway, New York, NY 10036

Layout and Design by Grant Bradford

Typeset by Tenreck Ltd.

Origination by York House Ltd.

Printed and Bound by Mateu Cromo Artes Graficas, S.A., Spain

Author's Note

Some of the experiments in the following pages are fairly straightforward; some quite difficult. It is assumed that the reader has some experience of darkroom work and photographic procedure and can process a black and white film, print a sheet of contacts and produce a reasonable black and white enlargement. If not, it is inadvisable to begin any experiment without first gaining some experience in the darkroom.

Many local camera clubs hold courses throughout the year or you might enrol in a class at the local evening institute or college of further education. There are also various publications, such as "Amphoto's Guide to Black and White Processing and Printing" by Douglas Manella, to help with procedures, time and temperature control, and equipment.

You will also need access to a darkroom, a light-box and an enlarger that has a colour head or provision for a filter drawer. Previous experience of printing in colour is not essential. A description of colour processing by two systems are on page 154 and it will be seen to be not very much more exacting than processing in black and white.

If you have only black and white facilities nine of these experiments can still be carried out. Having achieved acceptable and rewarding results in these black and white experiments it will encourage you to widen your horizons and move on to colour work.

All but one of the experiments can be done in a small home darkroom, and most of the photography can be achieved in a room about 12 feet by 9. I would advise you to read the complete text and study the diagrams of the particular experiment you want to carry out before you start work on it. (This is the kind of advice – often found boring and therefore ignored – given by most manufacturers to be followed before their products are used, whether it be wiring a plug to a toaster or setting up a TV game).

Although this book is essentially for the amateur photographer it is hoped that the student, the photographic assistant and the professional will find the procedures and formulae useful for reference, thus saving valuable time otherwise wasted in working by trial and error, and economising in expensive chemicals and materials.

Finally, the standard processing procedures are included in each experiment. I have done this so each experiment may be complete in itself without the need, when in the middle of working, to refer backwards or forwards to another page.

Contents

Experimental Photography

Introduction

In all my work as a professional I have always been fascinated by the kind of result that can be obtained by experimenting with the photographic process. Some of these results can certainly be bizarre, but so many can open up a whole new visual world obtainable only through the medium of photography.

This book is designed to explain as clearly as possible, with precise illustrations and layout, how to produce experimental photographs using various darkroom, lighting and camera techniques. A simple formula is used throughout the book. By taking a single subject, in this case a photographic model, and using care, imagination and sound photographic technique, a variety of images is achieved which will extend the reader's photographic horizons. Once the techniques have been mastered it is hoped the reader will go forward to create his own style.

Most photographic subjects can be used; portraits, child studies, landscapes and animals. There are few areas of photography that cannot be experimented with. Follow the procedures carefully, and with patience and sound technique quite surprising and interesting results will occur. This is the great fun of experimental work – sometimes it seems a monumental failure and then, just as you are about to give up, further work achieves altogether startling results. The secret is to persevere, even though at times it becomes difficult and frustrating. Patience is the key, but concentration, care and imagination are also important. Each step in the procedure must be carefully followed and double-checked; if not, disappointing results can follow. Obviously practice and experience are essential but I hope that 25 years of professional experience and its utilization by the reader, carefully following the advice given, will save hours of time, expensive film, paper and chemicals.

General Considerations

If choosing adult models, whether male or female, they must be photogenic, in other words ·they must understand the camera; should not be easily bored nor shy and introverted; must be interested in what you are trying to achieve – in fact preferably extrovert characters. Avoid at all costs girl/boy-friend, husband/wife, if they do not possess these qualities. It is helpful if you yourself are also interested in the model. Try to avoid a personality clash. Do not allow a strong personality to take over a photographic session, this is a major problem with extrovert characters. Do it your way or not at all. Your model may think she/he looks best from a particular angle; be firm and ignore this advice – you must be the judge.

When in a formal setting, such as a studio with artificial light-ing, consider how to persuade the sitter to relax and be them-selves; get behind the eyes and attempt to catch the inward grace, the personality. With bright, hot lights, pupils contract and eyes water, so carefully-prepared make-up can easily be ruined. First acclimatize the model to conditions before com-mencing to shoot. If you still have trouble resort to flash or natural light.

Do not spend large amounts of money on expensive backgrounds and lighting equipment if you do not intend to do a lot of studio-style photography. Adapt and make use of everyday objects around the house. For reflectors use projec-tion screens and white sheets; paste crumpled aluminium foil from a kitchen roll onto a piece of cardboard; paint a white wall with emulsion paint and direct a flood or a synchronized flashgun at it. All are very effective without going to great ex-pense. Rolls of photographic background paper can be costly and cumbersome. A tin of emulsion paint and a roller used on a plain wall are just as effective to get even backgrounds for black and white or colour photography. If you are shooting in colour and you use coloured paint on the background, re-member that the colour used affects the whole of the subject being photographed and not just the background, so avoid reflection of that colour onto the subject.

A single colour scheme is always effective for colour photo-graphy, e.g. if your model is wearing a red dress, paint the background a slightly different red; accessories such as ear-rings, head-scarves, jewellery and hats should also be red.

To get softer lighting on a model's face, diffuse your floods and flash units. For the floods a piece of translucent white Perspex fixed with a double bulldog clip in front of the reflec-

tor is very effective and even a piece of greaseproof paper taken from a kitchen roll will work (be careful though, support the diffuser away from the bulb or it will scorch or even ignite the greaseproof paper with the heat). With flash units umbrella reflectors can be purchased from a good photographic dealer and they are not too expensive. Alternatively flash bounced off a wall or ceiling can be surprisingly effective but this method has to be carefully tested. The exposure is determined by the strength of each individual flash unit and the distance of the wall or ceiling from the subject; only testing and experience can ensure accurate results.

In a studio setting keep the lighting simple. Commence any studio session with just one light directed onto the model; this is the key-light. Think of this key-light as the sun and keep it high and pointed down at the subject at about 45°; move it around until you are sure it suits the features of the sitter. Ask your model to remain still and then move in a second but less powerful and diffused light from the opposite angle/side – this is the fill-in light and should be treated as the reflected light of sunlight. An acceptable balance between the two lights, giving the subject form and depth, requires patience and practice. Further lighting can be added to the background and hair but only when the main light sources have been balanced. Take into account the height of the ceiling and the distance the sitter is away from the walls as this will affect the strength of the light reflected back onto the subject. Try to keep the colours of the walls and ceiling as neutral as possible; strong bright colours will affect the final results if colour film is being used.

By using artificial light, which is not as intense as daylight, you will need increased exposure to obtain acceptable result. This will mean a slower shutter speed or a larger aperture, perhaps both. A slower shutter increases the possibility of movement in the camera or by the model, and a larger aperture will decrease the depth of field. Camera movement can be eliminated by using a firm tripod; most people can remain still and not blink the eyes if you use a shutter speed of 1/30 sec. or faster. At the slower speed more care must be taken to ensure that the model does not move. With modern lenses the decrease in depth of field that a wider aperture gives is not so important as perfectly acceptable results can be achieved provided the shot is properly focused. If, however, even with the lens fully open the speed is unacceptable – i.e. 1/10 sec. or longer – it will be difficult for the model to look natural. In this event you will have to change to a higher rated film stock (e.g. Tri-X at 400 ISO/ASA instead of Plus-X at 125 ISO/ASA).

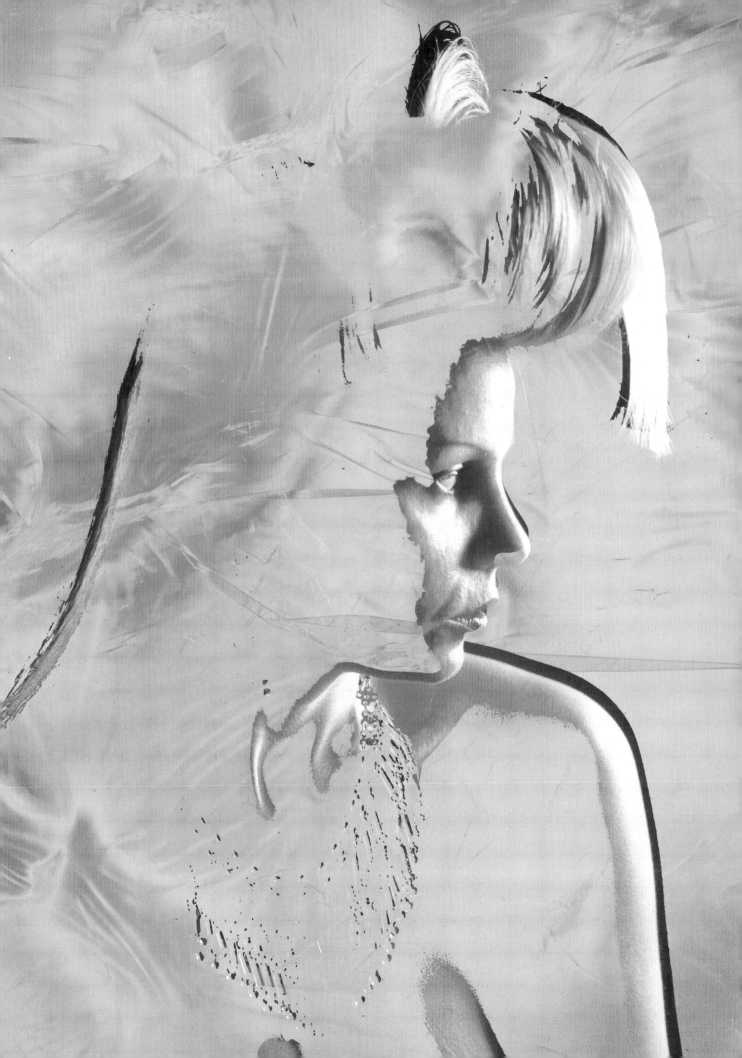

Definition is the key to a good photograph and poor definition is most often caused by camera movement, not by using a wide aperture.

Children

The most suitable age for photographing children is when they are under seven. After that they tend to become camera-conscious and giggly. Catch children unaware and at play; do not spend time trying to get them to smile at the camera despite wife/husband/gran's insistence: the best photographs of children have always been informal. Avoid sentimentality; only adults are sentimental, not children. Enter their world; children should be remembered for themselves, not what you wish them to be. Follow two basic rules:-

 1) keep it simple.
 2) be patient.

Animals

Patience again. Fast shutter speeds are essential because few animals remain motionless for any length of time if a camera is pointed at them. Use 1/500 of a second or at the very most a 1/125. If you are unable to get an aperture wide enough (i.e. reading at about the smallest f/number on the camera, 3.5 or 2.8 etc.) you will have to use a film with a higher speed rating.

With the increase in film speed, despite modern technical advances, some loss of quality is inevitable, so it is essential to calculate the exposure correctly. If you do your own negative processing either in black and white or colour, it must be very accurate and temperatures and times recommended by the manufacturers must be strictly adhered to. Wrong exposure and incorrect processing emphasise the grain, and detail is lost in the shadows.

Photograph animals whenever possible in pairs. A favourite trick is to pair enemies, e.g. cat and mouse, dog and cat, fox and hen. Animals rarely behave as you wish them to when the camera is at hand and they are almost impossible to set up. To attract the attention of some pets and to get them to look alert, a few sounds the animal either recognises or even dislikes can be recorded on tape and then played back to them from behind the camera position. This method however only works occasionally; the quality you need most is patience.

Landscapes – Seascapes – Sunsets – Dawn – Location Photography

Try to avoid obvious and hackneyed pictures – use your imagination: look at a scene from different viewpoints before selecting the one you think has the best lighting and most interesting composition. The camera is an efficient tool to be used precisely – do not let it dictate to you. Work simply: you can be guided by the work of a master such as the late Bill Brandt without slavishly copying him. The more effort you expend the more rewarding the result. Work and plan but enjoy yourself – a project should not become a task or an obsession.

Take your time and do not allow others to rush you or divert you. If a close acquaintance suggests "Isn't that charming?" and you disagree, ignore him/her; achieve your own objectives. When you finally have a result that pleases you explain your reasoning and motivation to the doubters.

Filters

Make use of filters to aid mood. Many of the modern filters are a trifle 'gimmicky', so be selective. With black and white film I normally use deep orange or red: the red to achieve very dark moody skies and the orange to enhance and emphasise cloud formations. With colour it is just the odd colour correction filter such as pale yellow and a skylight filter to cut down the ultra-violet end of the spectrum when it is very bright. Remember the more filters you put between the lens and the subject you are photographing, the more likely you are to lose definition.

Exposure

The correct exposure is all-important and it is essential to use an exposure meter. This leads to good quality and easier working. Only alter the exposure from the 'correct' in a controlled manner, i.e. to get a special effect. However with a tricky subject it may well be worth 'bracketing' the exposure: viz, if the exposure meter reads out at 1/125 at $f8$ make four more exposures:

1) 1/125 at $f11$. 2) 1/125 at between $f8$ and $f11$.
3) 1/125 at between $f5.6$ and $f8$. 4) 1/125 at $f5.6$.

Plus of course the exposure meter reading of 1/125 at $f8$ (5 exposures in all).

Generally observe two basic rules: 1) If it is dull – open up the lens. 2) If it is bright – close it down.

Darkroom and Darkroom Procedures

Keep the darkroom clean and tidy (surprisingly difficult) and if possible dust-free. Chemical contamination must be avoided at all times. Try to maintain a dry area away from running water. Dust is the major enemy: use a soft tissue to clean lenses, film and cover glasses. I find that puffers and brushes just shift the dust about. Check your enlarging lens regularly for dust and grease as dust on the lens can affect contrast, and grease-smears from fingers accidentally touching the outside of the lens when stopping down can also be detrimental.

If a negative gets dirty or greasy wash it first; add a spot of wetting agent to the wash and hang the film up to dry naturally in a dust-free area. If the marks persist on the emulsion side, rub the surface with a clean handkerchief and a spot of film cleaning fluid. The back of the film can be cleaned with the harsher petroleum spirit or methylated spirit, but make sure that the emulsion is lying on a soft pliable surface (a folded clean handkerchief) to avoid the emulsion getting scratched. If dust and marks are kept to a minimum endless hours of spotting and retouching are avoided.

Keep useful implements such as scissors and pencils handy in the 'dry' area and also keep paper and films safe in this area; close all boxes after each and every operation. Never, of course, turn on a white light without first checking that the box in use is closed. Plan your darkroom procedures and follow them meticulously.

With colour processing, planning in the darkroom becomes even more necessary: for certain periods total darkness is inevitable. It is important to keep essential aids in the same place, memorising where they are. Avoid distractions: take your time, get a clear image in your mind what you are trying to achieve and do not deviate. If something happens en route that pleases, treat it as a bonus.

Accurate exposure and development times should be maintained by clock or timer, and temperatures must be consistent. Every procedure should be noted down – this includes tests – the memory cannot be relied on for all details. Put simply: don't guess – test and you will save time, material and money.

If you are relatively inexperienced in darkroom procedures it might be as well to start with one of the easier experiments such as a line conversion and use it as practice before attempting a more complicated experiment such as a posterisation. By attempting something too elaborate in the early

stages you may find yourself struggling and disappointing results could follow.

Do not spend long hours in the darkroom unless you are used to it. If an experiment is unsuccessful, leave it and come back to it later; do not get bogged down on one subject for too long; if it constantly goes wrong abandon it and return to it later with a fresh idea.

Make certain that the filter in the safelight is correct for the process you are undertaking. This is particularly important when using Kodalith Ortho Type 3 4556 film. Kodak's recommendations for filters and bulb wattage must be strictly adhered to. All the electrical switches, for safety reasons, should be of the pull-cord type. This is particularly important with regard to the main white light; more often than not the hand is damp when a white light is required.

Colour

The bleach used in some colour processes can be particularly strong, unpleasant and corrosive. Rubber gloves and an apron should be worn, and the bleach disposed of greatly diluted with water, never poured straight into the sewage system untreated. Equally avoid contact with the skin and clothing.

For economical and consistent results with colour prints a rotary drum is essential; if you can afford it a motorised unit to operate it is a boon, but equally good prints can be obtained by rolling the drum by hand provided the rolling action is smooth and continuous at all stages – never erratic. These precautions are essential for clean, even prints, as are temperature control, correct filtration and adherence to manufacturers' instructions. The drum must be washed out thoroughly with clean, hot water each time a process is completed, and dried thoroughly – either naturally or with a clean towel. Do a test-strip for every print; in the long run this saves hours of time and expensive paper and chemicals. Each test-strip must be logged along with written notes and then filed. Note on the back of every test the following:
1) Exposure
2) Enlarger aperture setting
3) Filtration
4) Size of the complete image on the baseboard and the size of the negative or transparency in the enlarger's carrier or, if a scale is provided, the height of the lens panel from the baseboard.
Never throw away a test unless it is completely blank. Even

the test that is a long way from 'normal' gives some information, however slight. The reason for logging the image size on the baseboard relative to that of the size of the negative/transparency in the carrier is because the larger the image projected onto the baseboard the more exposure it requires to obtain a correct result, and despite the different densities to be found in negatives and transparencies, it is surprising how consistently the sizes on the baseboard, the sizes of the negatives and the transparencies, and the exposures relating to those sizes, match over a period of time.

Most experimental work is darkroom work. Get the darkroom procedures and the techniques correct and accurate and first-class results are sure to follow.

Cameras and Lenses

Expensive cameras and lenses do not necessarily equate with good photography. Batteries of expensive zoom, telephoto and wide-angle lenses are not really essential to achieve acceptable results. All the photographs in this book (except one) were taken with just two standard lenses: that on the 2¼" sq. (6 x 6 cm) and the one on the 35mm camera.

The general rule for cameras is simply: 'if it suits you and you get a result that pleases, continue with it'. A reasonable camera with a good range of speeds from a 1/500 of a second down to one second is however required if you are to succeed with all the experiments in this book. A simple cartridge loading type of camera will not have the flexibility.

Film and Papers

Try not to use one brand of colour film with a different brand of paper and do not process one make of film in a different maker's developer unless you are experienced. Be consistent. To advise on actual films in general is impracticable: a guide is given with each experiment but it is only a guide. If you get a pleasing result on a particular film stay with it.

General Photographic Equipment

Photographic equipment and accessories can be expensive but it is not absolutely necessary to go to great expense purchasing elaborate aids. Use the objects to hand – adapt, invent, compromise even. A pair of floods, a small spot maybe, a flash unit and a small serviceable secondhand enlarger should see you through.

General

It is useful to get a theme or subject that interests *you*. No matter how mundane the subject appears to be, if it is approached with care and enthusiasm and is a singular and personal point of view, the concept as a whole will work. Try not to be tempted into ideas that are too complex. Most of the large scale enterprises have been done so many times before that your chances of producing an original concept are slim. It is much more profitable to take a seemingly ordinary subject and achieve a personalised set of prints. Get your objective clear and then use the techniques. Please yourself first; all the great photographers have shown self-indulgence. Having said that, make sure you have the consent of any model you may use, and if on private property, get the owner's permission. Never use or abuse other people just to get a result.

Get relatives, friends, models and acquaintances to enter into the spirit of your project. Black and white, sepia, colour; all will work if the idea is right in the first place.

Allow the imagination to wander but retain your self-discipline. The usual photographic disciplines can be stretched but never ignored. The basics, such as the correct exposure, careful and precise processing are all-important to give a stable base on which to build. Once you have that, the other procedures and processes become easier to perform.

If you think you can take any of these techniques one or even two stages further, do so by all means, but make sure it 'reads'. Do not produce an effect just for the sake of it, make sure your original idea has substance. Use the information in this book only as a guide. The concepts must be yours.

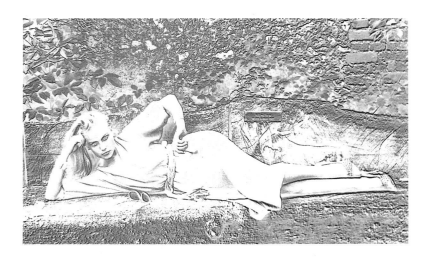

Victorian Vignette

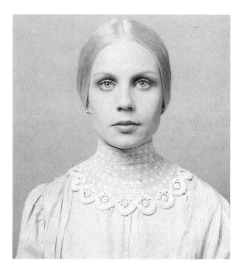

Print from original
negative

This technique, so popular with early Victorian photographers, used with forethought and careful procedure, can look surprisingly up-to-date. The effect of the oval surround to the subject is achieved by the use of a mask during printing, and the final print is sepia toned.

In the Studio

Children, pets, couples and head and shoulder portraits of pretty girls make excellent subjects for this technique; male adults seem only to work well at full length.

For a portrait first consider the following points: if possible study some Victorian photographs, at the way they are lit and the general feeling they give of the period – the aim being not so much to copy as to use the mood in your experiments. Softness of tone is very important, harsh lighting is to be avoided; carefully study hair and make-up, ensure that eye shadow and rouge merge, and that lipstick is not too bright or too shiny. A woman's dress should be soft, lacy and feminine. Low necklines are to be avoided and the sitter should look serene and relaxed. Try to create in your mind's eye the finished portrait you want before taking any photographs.

Lighting

This is crucial to the final result. Avoid harsh shadows; use two flood lights and diffusers. This can be achieved with white translucent Perspex sheets or greaseproof paper in front of the lamps; do not fix this material directly to the reflector or it may scorch or even burn: use double bulldog clips to give an air space. Use one lamp as a key light and one less powerful as a fill-in, (fig. 1) or use a reflector (fig. 2). You can also use daylight through a window but diffuse it, for example through a net curtain, and use it indirectly – never use direct sunlight. Under these circumstances, place a white projection screen, a white sheet or card to fill-in and soften the shadow.

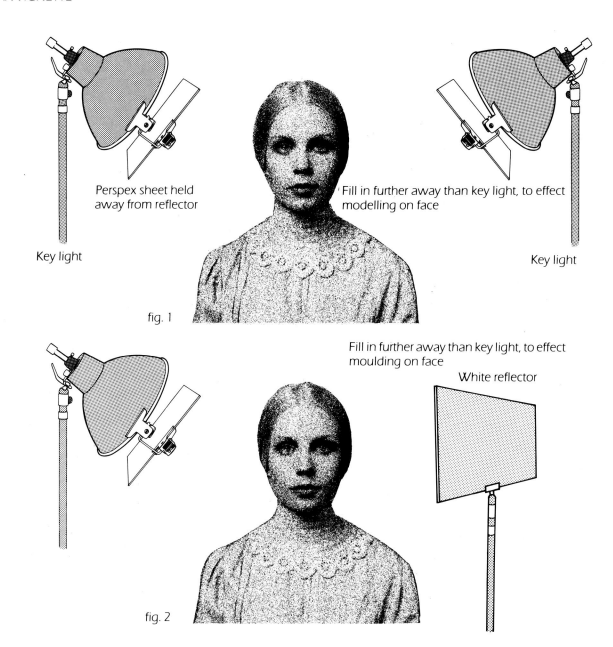

Perspex sheet held
away from reflector

Fill in further away than key light, to effect
modelling on face

Key light

Key light

fig. 1

Fill in further away than key light, to effect
moulding on face

White reflector

fig. 2

Double bull-dog clip

If you are fortunate enough to have two flash units with um-brellas, use one on full power as a key light and one on half power as a fill-in. If you only have one flash unit, use it in the same manner as daylight with a reflector. Do not use flash di-rectly without a diffuser as it is much too harsh. You may also use bounced flash off the ceiling or opposite wall if suitable. Aim to get the right lighting balance even if this means expos-ing a test roll of film. Alter the distance of the key light or the fill-in reflector, but not both at once, until you are satisfied with the lighting balance. Keep a note of the distances and the exposures.

Background

Choose a plain grey background, making sure it is even. Alternatively a white background may be used with the model seated some two metres from it. This will give a medium grey depending on the light source.

The Camera

A 35mm or 2¼" sq. (6 x 6cm) is adequate. With either camera use a slightly longer focal length than normal, if possible, to decrease the possibility of distortion. I prefer a 105mm lens on a 2¼" sq. to give me more control. However, do not let the consideration of lenses and cameras influence you too much.

Film and Exposure

Avoid grain at all costs and use a fine grain film such as Panatomic-X (32 ISO/ASA,) for 35mm and Plus-X (125 ISO/ASA) for the 2¼" sq. format. Be accurate with the exposure – trust the meter and do not guess. Avoid over-exposing your negatives as this will only increase the grain.

Definition

Get a sharp image focusing on the eyes. When using floods or daylight through a window, use a tripod to avoid any likelihood of movement. Even if you decide to use one of the modern diffuser filters over the lens make sure you are correctly focused. Good definition is the key to success.

In the Darkroom

Develop in Microdol-X according to the manufacturer's instructions. Agitate for at least 15 seconds every minute. Maximum quality throughout the middle greys is essential. Fix for 5 minutes. Use a spot of wetting agent at the end of a final wash of 10 minutes and then hang the negatives on a line allowing them to dry naturally without heat, in a dust-free area and then cut and place them into negative sleeves immediately. Treat the negatives with the utmost care and consideration – in the long run it saves time in endless spotting. Keep fingers off the emulsion, handling by the edges only. Make a set of black and white contact prints and then select a frame suitable for a vignette.

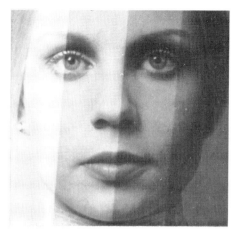

fig. 3
Test strip 2, 4, 8 and 15 seconds

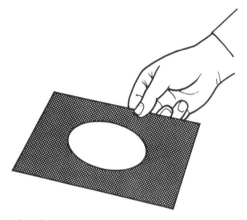

fig. 4
Oval is one-third less than that required
in the projected image on baseboard

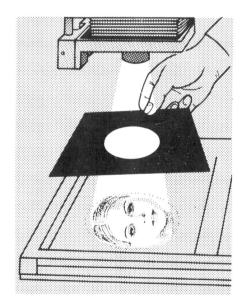

fig. 5 Keep mask square

Enlarging, Masking and Processing

This technique should not be attempted with a print less than half-plate (6½" x 4¾") as it is much too fiddly. A 10" x 8" is convenient and easy to manage. A test strip should be made on bromide paper to determine the exposure (fig. 3.). Try to achieve a soft result in the test, as if it is hard, the final print in sepia will be too dark and ginger. With a normal negative Kodak Grade 1 paper is ideal, but do not be frightened to go down to Grade 0. Keep the greys soft and subtle. Develop fully in Kodak DPC print developer diluted 1-9 for at least 1½-2 minutes at 68°F/20°C; if not fully developed the final sepia print will not redevelop correctly or evenly. The enlarger should be well stopped down as a longer exposure than normal in black and white printing is required to give more flexibility when making the soft edge on the oval. Aim for an exposure of at least 10 seconds, preferably 20. Use a stop bath and then fix for 3 minutes. Rinse and dry the test.

Next cut the mask from stiff cardboard, such as an old cornflakes packet, and paint it black with water colour if possible to avoid unnecessary reflections (fig. 4). The oval needs to be cut accurately and about one-third less in size than that required in the projected image on the baseboard as the agitation of the mask takes place above the printing paper. If possible project an ellipse guide in your enlarger to give an accurate outline on the card; it may be pencilled in and then cut. When prepared, and with the negative in the enlarger, switch on and hold the mask about half-way or less between lens and baseboard to get a rough guide to the final image (fig. 5). Check that the size of the oval is correct and alter it if necessary. You are now ready for your final exposure on a full-size piece of paper.

This has to be made with the mask held in the position determined: it must be kept as square as possible, and moved with a gentle circular movement (fig. 6) – and it is this movement which gives the oval of the print its soft blurred edge, and where a long exposure is so useful as the extra time gives more control. (If decreasing the lens aperture fails to lengthen the printing time sufficiently, more time can be gained by using a neutral density filter over the lens).

It is obvious that an enlarger equipped with a swing filter (orange or red) or a footswitch, or even both, will help your manipulation considerably. You will be able to see the position of the mask, even with the paper in place, before either moving the filter gently out of the way for the exposure, or

switching off – moving the filter away – and switching on again to expose.

Without these advantages you will have to 'rehearse' the position of the mask before putting the paper on the baseboard. Try it several times until you are satisfied you can get the mask in its correct position by the time you switch on and begin the sieve-like movement. One trick I have sometimes used under these circumstances, but only when the exposure is prolonged, is to hold the mask closer to the baseboard initially – where it will pass only a small area of the image – and raise it quickly but gently to the operating position, after switching on. Once your paper is exposed process it for 1½-2 minutes in the Kodak DPC (diluted 1-9) print developer at a temperature of 68°F/20°C. Use a stop bath and then fix for 5 minutes. Wash thoroughly for at least 15 minutes to eliminate the hypo, or streaks and marks will occur on the final print. Do not dry the print; once it is thoroughly washed go straight on and do the sepia toning.

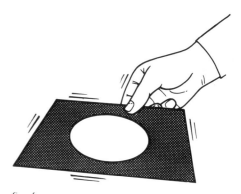

fig. 6
Move mask with a gentle sieve-like movement

Sepia toning

The chemicals can be bought in a twin pack from your photographic stockists. Follow the instructions exactly; the print is bleached until the image disappears and is then rinsed until the yellow chemical disperses. Darken in the sulphide (fig. 7). Wash the print for ten minutes, dry and mount the final print.

Bleach until clear

Rinse until yellow disappears

fig. 7

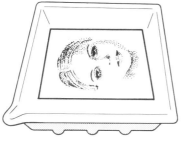

Re-develop in sulphide

Line Conversion

The line conversion is probably among the most popular techniques in use today and the media themselves are mainly responsible for this. The reproduction of half-tone photographs in newspapers and magazines is the bane of the publisher's life. The easiest way to get satisfactory reproduction from small photographs is to reduce the photograph to line and make a line block; but by taking this easy way out the media have abused the technique to some extent. The selection of subject matter for line conversion requires some thought; the way many subjects are photographed is simply not suitable for reduction to line. A long list of subjects would perhaps confuse the issue. However, a photograph that does lend itself to this treatment should, on the whole, have strong lighting and harsh shadows. Think of possibly the most famous line conversion of all, the photograph of Che Guevara with the black beret, the high cheekbones, the deep sunken eyes and their shadows. Although the middle greys have been eliminated the essence of the photograph and its mood have been retained. The key question to ask yourself is: "if the middle greys are lost will the photograph still 'read'?". You need to retain some of the mid-tones which although eliminated are in evidence in the shape of small dots. Indeed it is these small dots which give this kind of print much of its appeal and a fair proportion of them must be retained to give the subject matter form. In fact these grey areas are so important that later on in the experiment they are concentrated upon, and the technique for enhancing them is described in some detail.

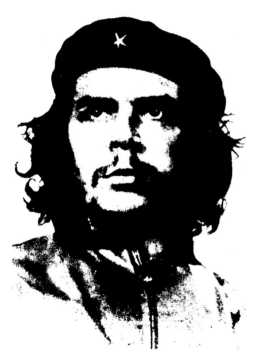

On Location or in the Studio

Take the camera on location and seek out interesting shapes with cross-lighting. Even a brick or stone wall with textured lighting on it will suit a line conversion. An industrial subject such as an oil refinery has strong definite shapes, and busy night shots, especially just after it has stopped raining reduce to line very effectively.

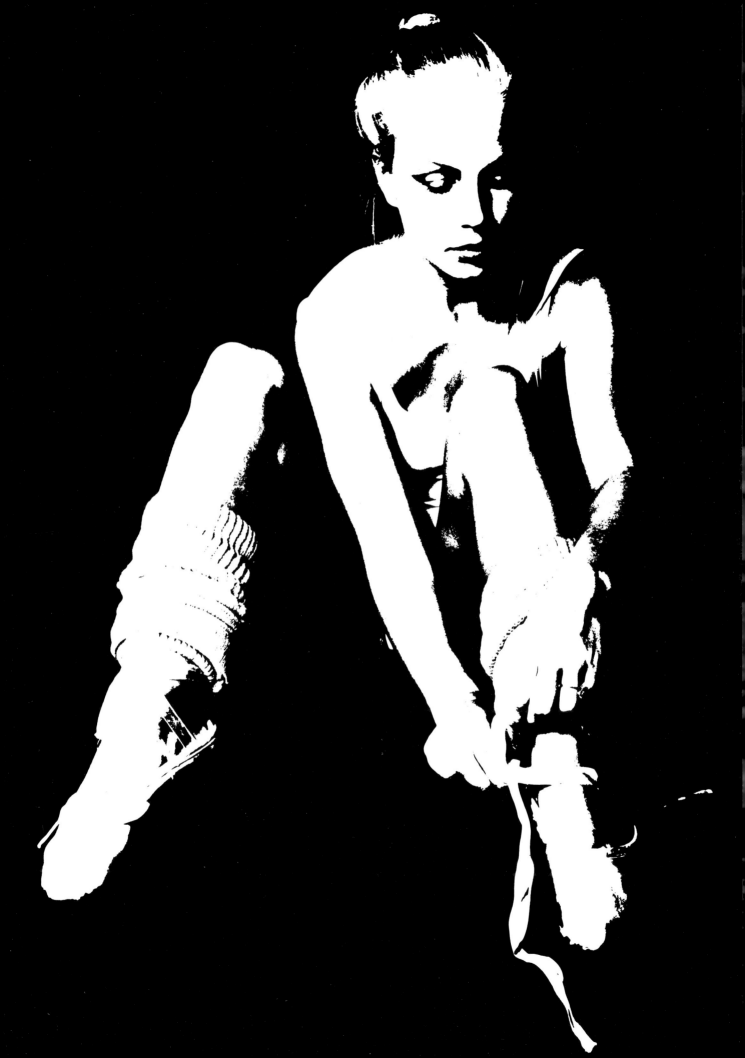

fig. 1
35mm enlarged to 2" on 5" x 4" film

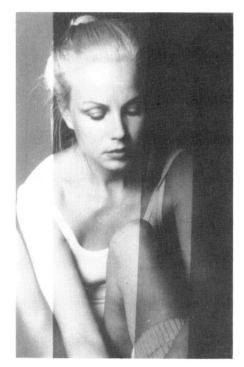

fig. 2
Test strip (positive) 2, 4, 6, and 8 seconds

fig. 3
Contact 2¼ to one side of 5" x 4" film

If you do decide upon a location shot and it has a cloudless blue sky, use a red filter, this will make it dark and moody.

Studio portraits however have to be approached with some care. I have found that one strong key light high up and directed downwards at about 45° without a fill-in or a reflector is the most successful lighting for this technique.

When you have decided upon a subject, photograph it in black and white with Tri-X (400 ISO/ASA) or Plus-X (125 ISO/ASA). Process the negative in fine grain developer (Microdol-X) but increase the development time by two minutes over and above the maker's recommendation. This will give you strong punchy negatives with good contrast between the highlights and shadow detail. From a set of contacts select a frame you think will be suitable to convert to line.

There are two methods for converting half-tone to line. The first is described on page 100 in the Sepia Posterisation experiment.

In the Darkroom

I prefer this first method, working totally in the darkroom, because it gives me more control. It is important to use as large a negative size as possible: the larger the size, the more acceptable the result, and it is assumed that a 2¼" sq. enlarger is available. If not, a good result can still be achieved on 35mm; it is, however, much more difficult to control. A 35mm black and white negative should be enlarged to 2 inches wide on 5" x 4" film (fig. 1). If you have a 2¼" sq. negative, contact it to retain the maximum definition. Use half a sheet of 5" x 4" Kodak Reproduction 4566 line film, handling it by the light of the correct red safelight filter and expose a test-strip in the normal way (fig. 2). It is important to develop the test fully in Kodak DPC print developer for at least 2 minutes at 68°F/20°C. Fix and rinse the test, dry and then view over a light-box. You will have a positive film test-strip. By using the print developer you should have a result that is bright but with not so much contrast that it loses too many of the middle greys. Choose the exposure that looks correct. i.e. the exposure with a reasonable range of tones, bright highlights and deep blacks.

Expose a full sheet of 5" x 4" Reproduction 4566 with the image to one side (fig. 3): you will need this extra film later on. Develop as the test, fix, wash for 3 minutes and dry.

Before attempting the next step make sure you are set up as the illustration in fig. 4 shows.

You need two dishes; 6½" x 4¾" or 10" x 8" will be sufficient, a sheet of clear Perspex, or glass with a bevelled edge, some cotton-buds or a fine sable brush, a plastic beaker, a safelight with a red filter (a small beehive is ideal) at eye-level, and a second sweep-hand clock or darkroom timer. The sink should have cold running water available.

The Negative Process

The development for the line conversion negative is Kodalith Super Liquid and the film is Kodalith Ortho 4556 Type 3. Note that the developer is in two separate solutions which should be mixed according to the maker's instructions only when you are ready to use it as its working life is comparatively short. Pour out the developer and the fix and fill the beaker with warm water (90° – 100°F/32° – 38°C).

Place the positive film image in contact emulsion to emulsion with half a sheet of the 5" x 4" Kodalith film in a contact printer or under a sheet of glass (fig. 5). Make sure the glass is throughly clean, this film is very prone to collect and emphasise dust. Expose it as a test-strip. Develop for 2¾ minutes with continuous agitation, fix, rinse and then dry. To decide the best exposure of the test to give maximum quality in the final print comes only with experience. It can also be a matter of taste, as one would discover by taking the test through to a final print – although this could make the whole experiment rather long-winded. An easy way when first starting this work is to take the middle exposure of the acceptable ones, but you must bear in mind that those on either side could also be acceptable, but would give a different 'feel' to the final image by drastically altering the balance between the shadow and the highlight areas.

fig. 4

From the test you should be able to see the areas that will require enhancing. This is the reason for the warm water, sheet of Perspex and the cotton-buds. Some of the shadows need extra development (these are the clear areas on the negative and their position should be noted).

Red Safelight Darkroom clock

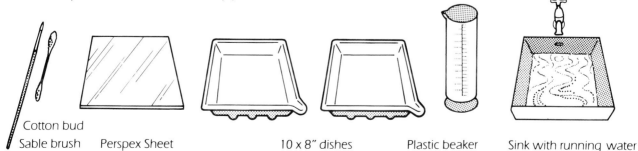

Cotton bud
Sable brush Perspex Sheet 10 x 8" dishes Plastic beaker Sink with running water

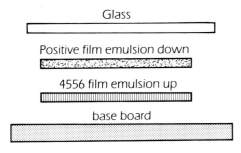

Glass

Positive film emulsion down

4556 film emulsion up

base board

fig. 5

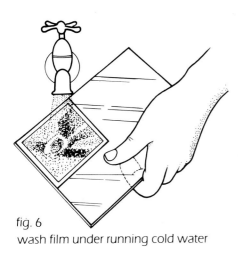

fig. 6
wash film under running cold water

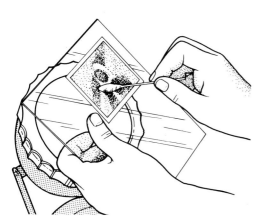

fig. 7
Tickle-up shadow detail with cotton
bud, warm water and developer

Take a sheet of 5" x 4" Kodalith and make a contact exposure of the whole sheet as in fig. 5, exposing it according to your assessment of the test-strip. Start the clock and commence development. At about 60 seconds lift the film from the dish, this is where the extra film around the image is so useful, as heat from the finger and thumb can cause streaks and marks. Wash the film for 15 seconds under a running cold tap (fig. 6). Place the film emulsion up on the sheet of Perspex and check it by the safelight. Shadow areas (the clear areas on the negative) will show at this stage. Dip the cotton-bud/brush first in the developer and then in the beaker of warm water and gently brush or rub the clear areas (fig. 7), being careful not to allow the liquid to run onto other areas. 30 seconds or so should be ample but experience will give you an accurate assessment of the time required. After 30 seconds replace the whole negative in the dish and continue its development for a further 1¾ minutes. Fix for 3 minutes and wash for 5; hang to dry in a dust free-area. When dry view over a light-box for dust spots; if any are in evidence spot them out with opaque and a fine sable brush, or an ultra-fine black fibre-tipped pen can be used if opaque is unavailable.

Cut down the film accurately to fit the carrier in the enlarger and make a print at about 10" x 8". Do not be tempted to print on a very hard grade of paper just because it is a line negative: you still need to retain some of the mid-tones. The greys that have been 'eliminated' will still be fractionally in evidence in the form of small dots. A fair proportion of these dots must be retained to maintain the form of the original subject. Acquiring this skill of capturing the original form of the subject requires practice and patience. The dividing line between a good result and an indifferent one is surprisingly narrow.

Select a paper grade of 3 or even the normal 2 and expose a straight print without dodging. If the balance between highlight and shadow is incorrect, return to the negative stage and make adjustments. Increase or decrease the enhancing in the shadow areas as required.

Wash your final print for 10 minutes, mount on card and spot if necessary.

If you only have a 35mm camera and enlarger make sure that you do all the negative/positive stages of the film processing contact and so retain maximum definition. To attempt to enhance the shadow areas at 35mm is inadvisable: it really is too small. But do not be put off by this consideration. Excellent line conversions are produced at the 35mm size by processing straight or using method 2. (page 100).

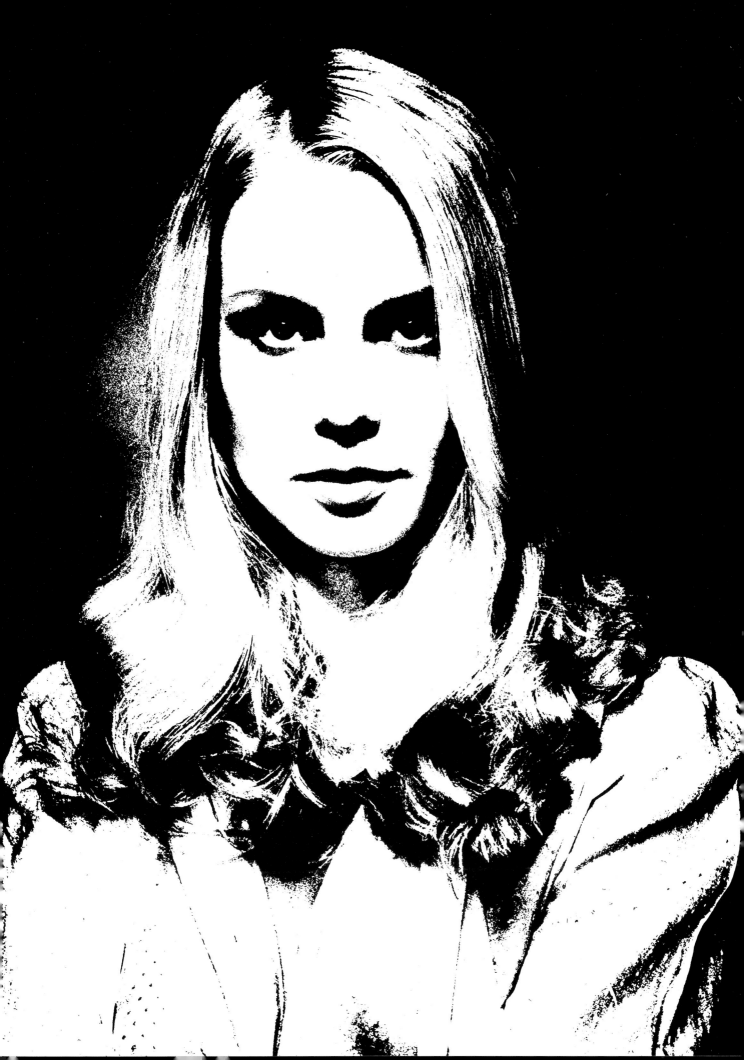

The Hand-Coloured Half-Tone Sepia

This is an experiment to stretch your artistic ability. The quality of the final print has a fine dividing line: too much tinting and the print becomes garish; too little and the print looks insipid.

You will need a set of colour tints and a good quality sable brush for the last part of your work on the print.

This method works very well on a portrait as illustrated, but a landscape with a moody sky and discreet tinting can also be very effective. Discreet use of the tints is important. The point to remember is that the print is a combination of sepia-toning and touches of colour added to strategic areas. The balance in the use of colour by hand is a question of personal judgement. The wrong balance and the print can be a failure.

The lighting on this particular portrait is radically different from recognised portrait work so it might well be worth following.

In the Studio

Use a white background such as a painted wall or a white projection screen large enough to cover the head and shoulders. The sitter's make-up should be carefully applied, and should be heavier than for everyday wear. Particular attention should be paid to the eyes which must be more heavily shaded than usual, merging the eye shadow with the rouge and with not too much contrast between them. There must be intermediate tonal values between the darker and lighter areas (fig. 1).

A shiny nose and cheekbones must be avoided by using good old fashioned facepowder: in an emergency french chalk is very effective. Lipstick should be medium red to achieve contrast but again it must not be shiny. The hair style should be left to your model, keeping in mind the style of make-up that has been applied. A bare neck and shoulders will help with the final print; ask your model to wear a bikini top without shoulder straps.

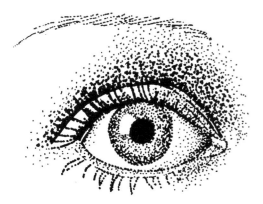
fig. 1
Rouge and eye shadow merge

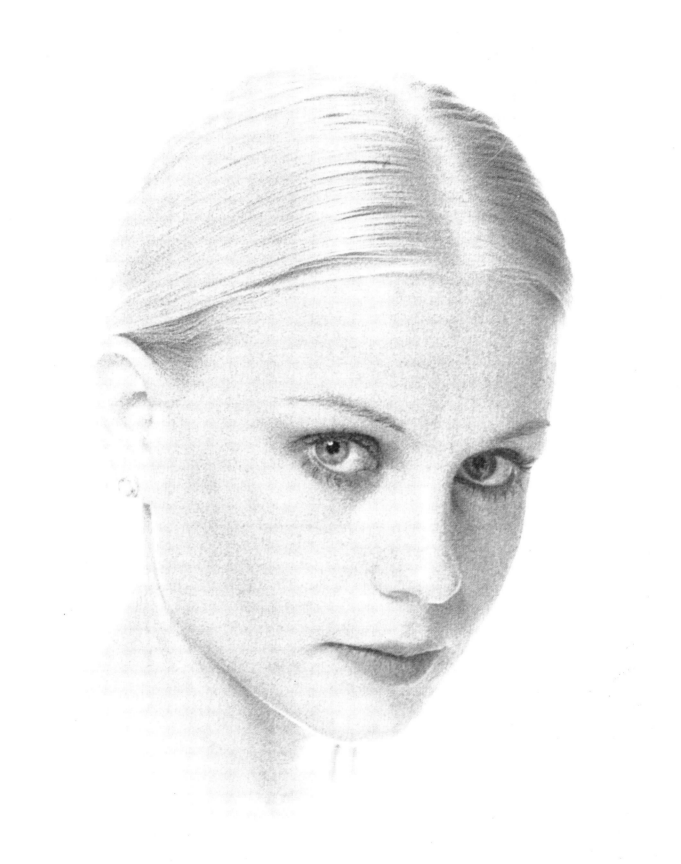

Equipment

A 2¼" sq. (6 x 6cm) or a 35mm camera – an adequate tripod – one flood suitably diffused – an electronic flash unit or gun (figs. 2-3) – a long synchronizing lead that is at least 2 metres long (this can be purchased from most photographic dealers) and a piece of white card (20" x 16").

Set-up

The flash unit or gun should be clamped on a stand directly behind the model's head (fig. 2) i.e. pointing towards the model's head and the camera, and not towards the background. It should be about 12 inches away from the back of the head. The synchronizing lead should run down the stem of the stand and then around to the camera. From the front the view should be that the flash unit, stand and lead are covered by the head and figure of the model. Once this has been achieved the model has to be requested to remain still so that the lighting can be assessed from the front. One diffused floodlight should be brought in as close to one side of the camera as possible and be at about eye level or just above (fig. 3). On the opposite side a piece of white card (20" x 16") (or a pillowcase stretched across a piece of hardboard) should be used to lighten the shadows. You may need some help in this operation so that the card can be moved away from the model with great precision until you are satisfied that there is correct balance between the diffused flood and the white card. Try to get modelling on the face, i.e. a great deal of depth to it. From the tip of the nose to the back of the ear is a particular and measurable distance so make sure that this distance becomes 'real' on the final print. A good head shot contains depth and good balanced lighting will achieve this.

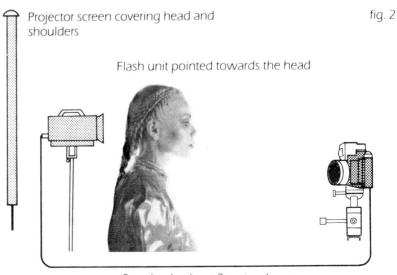

Projector screen covering head and shoulders

fig. 2

Flash unit pointed towards the head

Sync lead at least 2 metres long

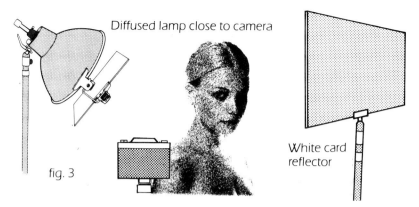

Diffused lamp close to camera

fig. 3

White card reflector

When you have reached a satisfactory lighting balance, and before loading a film into the camera, check that the flash unit synchronizes by firing the shutter a few times. At the same time make sure that the model's head is covering the whole of the front of the flash unit as obviously the flash must not be allowed to fire straight into the lens. If you have a large flash unit (400 Joules), put it on half power.

The light should be allowed to spill around the head when the flash is fired but not to such an extent that it flares into the lens. Check before each exposure that the model's head has not moved sufficiently to let this flaring occur.

Film and Exposure

Load the camera with Kodak Plus-X Pan film (125 ISO/ASA.) and take an exposure meter reading on the sitter's face. Ignore the flash unit and its light source. This portrait needs to be sharp with a good depth of field so try to get the aperture setting down to *f8* if it is at all possible. The shutter speed is bound to be longer than 1/125 of a second, so make sure you are using an adequate tripod. Do not fall into the trap that because you are using flash, movement is eliminated. The shutter speed, so therefore the exposure, is determined by the artificial lighting on the front of the model. Run off a complete roll of film to give yourself a wide choice; although the head position must be static the facial expression may be varied.

In the Darkroom

Develop in Microdol-X for 7 minutes at 68°F/20°C. Fix, wash for ten minutes and dry. When dry, expose and process a set of contact prints. The face and the background will be very flat in contrast and there will be a halo effect around the head caused by the excess exposure from the flash unit. Consequently the negatives will have a curious flat look but for our purposes this is correct.

Place the negative of the shot you have chosen in the enlarger

7½"

fig. 4

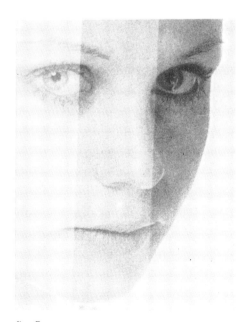

fig. 5
Test strip 6, 9 and 12 seconds

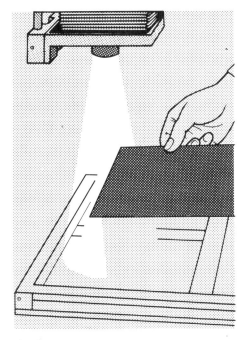

fig. 6
Fade off shoulders, holding back with black card

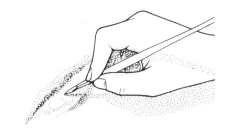

fig. 7
with water trace round lips

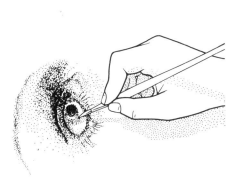

fig. 8
Colour eyes if thought necessary, but be very subtle

and enlarge the head to about 7½ inches within a 10" x 8" (fig. 4). Expose and process a test-strip across the face of the model (fig. 5), ignoring the edges of the head and the background. The tonal values across the face should be even and heavy shadows should not be in evidence. Keep the contrast as high as possible: the greys should not be flat or the whites lost in the highlights. Because of the light-flooding caused by the flash unit you will probable find a grade 3 paper is required.

Once the exposure has been determined in the area around the nose and mouth, from the viewing of the test, expose and process a complete 10" x 8" print. The shoulders should be faded off utilising a piece of black card. Keep it moving to get the soft-edge effect. (fig. 6).

Develop the print in Kodak DPC print developer for 1½-2 minutes at 68°F/20°C, fix, wash the print thoroughly for 20 minutes and then sepia tone it. (As discussed in experiment 1).

Finishing the Print

Dry the print and lay it on a piece of blotting paper. Pour some water into a saucer or a small paint palette and choose a red or vermilion from the pack of dyes. Take a sable brush (No. 1) and with water only carefully trace around the lips. (fig. 7). This prevents the dye from spreading to other areas of the print and it also helps to get an even base, thus making it easier to build up the colour.

Dip the brush into the red dye and mix a brushful with water to make a pale red. Test the brush on blotting paper first to check that the red dye is not too strong. Brush this solution of weak red dye carefully several times over the area of the lips. After each operation blot off the surplus moisture. Build the colour up slowly and evenly until it is to your liking. Never use the dye neat straight from the bottle. This building up of the colour is most important to get the print to look correct. Once the lips are to your liking, repeat the operation with appropriate colour on the eyes (fig. 8), making sure that you have a clean brush and water for each separate colour used. The colours must be muted and subtle in keeping with the lighting and the mood of the photograph. If you are using a landscape as a subject, with a strong sky and harsh shadows, the dyes can be relatively stronger but they must enhance certain selected areas.

This particular print is still basically a sepia tone. The colour is used only to enhance the final result, not to detract from it.

Reticulated Image

Reticulation – the bane of the photographer's life in the early days of photography. In fact it is only in the last twenty years or so that the manufacturers have conquered the problem. The effect was quite common to photographers and lab technicians up until the 1960's but the public rarely saw the results as reticulated negatives were seldom printed, simply thrown away in disgust.

The effect was caused by a sudden change in the temperature of the chemicals being used whilst processing black and white negatives, e.g. if a negative was developed at 68°F, fixed and washed at say 40°F chances were that reticulation would occur. The emulsion would move very slightly on the gelatine; consequently, whilst drying, the emulsion hardened in a wrinkled formation instead of being even. Sometimes the effect was so bad that the emulsion actually worked free, melted, and ran down the film or plate when subjected to heat in a drying cabinet.

Following constant complaints from the photographic trade, the manufacturers made great efforts to overcome the problem successfully and produce emulsions that could withstand wide variations in temperature and thereby reduce the chances of reticulation; this, of course, makes our task extremely difficult now that we want to get the effect deliberately!

I have adopted the following procedure to overcome the stability of the emulsions now achieved by the manufacturers.

By subjecting the emulsion to extremes of temperature under control and by carefully monitoring the times of each step in the procedure I achieve a reticulated emulsion at practically every other attempt.

Be warned, however, this procedure is still very much an experiment so do not under any circumstances attempt a reticulation on an irreplaceable negative. Set up a subject just for

this process: a studio still life or life figure is ideal. If your first attempt does unfortunately go wrong at least it will be fairly easy to set up again.

In the Studio

If you use a model ask her to adopt a pose that is easy to repeat. Likewise if the subject chosen is a still life, keep it simple and uncomplicated. The lighting should also be straighforward and easy to duplicate.

Film

Both Tri-X and Plus-X have been tested and both work. For my own experiment I used Tri-X and exposed a complete cassette of 35mm (20 exposures) exactly to the meter reading. If you use a 2¼" sq. (6 x 6cm) expose the complete twelve.

When winding back the film on the 35mm camera, listen carefully for the film to leave the take up spool. If you leave the tab out (just as when you buy it) you can easily pull the film out halfway and cut it in complete darkness in the darkroom thus leaving a further strip of film for a second attempt if the first one fails.

In the Darkroom

You must use a stainless steel processing tank and spiral (plastic will not stand the excessive temperatures required later on in the procedure).

The developer is Kodak Microdol-X undiluted at 68°F/20°C. The fixing solution is most important and must be non-hardening. To prepare, dissolve 4 gms of sodium thiosulphate (hypo crystals) in 100 ml. of water. The reason for fixation without a hardener is to help keep the emulsion as soft as possible. I carry out the reticulation after the first fixing stage – any hardener in the fix would prevent the emulsion from becoming soft enough. I have tried raising the temperature of the developer to increase the softening effect on the emulsion further but the disadvantages far outweigh the advantages. The quality of the negatives is so impaired by the short development times that become inevitable that I keep the developing time standard.

When you have the developer and the fix prepared, fill a large jug with water and add some ice cubes to it. Make sure the clock is ready and that a pair of scissors, Sellotape, tank and spiral are in place and turn out the white light.

fig. 1

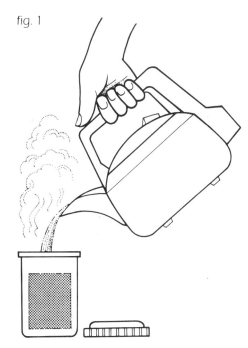

Pour boiling water over spiral of negatives in tank, let it stand for 30 seconds

fig. 2

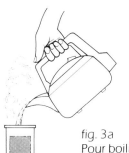

Pour iced water over negatives, let it stand for 2 minutes

Pull out half of the film from the cassette (this can easily be done if the end tab has been left sticking out as previously mentioned), cut and load it into the spiral and then place in the tank. If you use the 2¼″ sq. format, strip off half the film from the backing paper and Sellotape up the remaining half. Close the lid and develop in Microdol-X for the time recommended by the manufacturer.

Fix the negatives in the non-hardening fixer for 10 minutes and then pour it back into its container (you may need it later). Take the tank to a sink, boil up a kettle of water and pour boiling water over the film in the spiral (fig. 1). Then move the kettle away to a safe place to avoid accidents. Leave the film in the hot water for 30 seconds and then with an oven cloth or wooden laundry tongs (the stainless steel tank will be more than a little hot) pour the water away and promptly refill the tank with iced water from the jug. (Fig. 2). Let it stand for 2 minutes. Whilst this is standing boil up the kettle again. Pour away the cold water and fill the tank a second time with boiling water but this time leave it for 2½-3 minutes. Pour away the hot water and finally refill the tank with iced water, letting it stand for 3 minutes (fig. 3).

Carefully remove the film from its spiral. The emulsion will be very soft indeed and it will scratch and mark at the slightest touch. The film will look very sorry for itself, rather wrinkled and bits of emulsion may even be starting to flake off, but it should have reticulated.

If the emulsion has stripped of completely, reduce the boiling water stage time by 50%. If the emulsion has not moved, increase the boiling water time by 50%. The success of the experiment does unfortunately vary somewhat with darkroom conditions so the time given can only be a guide.

The film does become quite wrinkled so making it difficult to print a set of contacts; I rarely contact reticulated negatives for fear of damaging the emulsion still further and instead choose my frame by inspection.

If the film is badly wrinkled it will be very difficult to get flat in the carrier, but the problem can be solved by squeezing it very

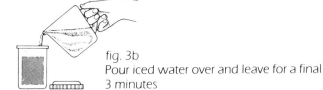

fig. 3a
Pour boiling water a second time, let it stand for 2½ to 3 minutes

fig. 3b
Pour iced water over and leave for a final 3 minutes

gently between two 6 x 6cm cover glasses. Tape the edges with Sellotape (fig. 4), this will help to get the film flatter but be careful not to damage the emulsion further. When you have this made-up carrier in the enlarger make sure that all the excess light that will inevitably spill out is masked off with black paper and masking tape.

Resist the temptation to print on a hard grade of paper to emphasise the break-up of the emulsion; keep the print soft and subtle. I prefer a reticulated print to look like a soft pencil drawing.

Make a first class 10" x 8" print with as wide a range of tones as possible and then mount it on card.

If this experiment proves nothing else, at least it shows how thorough the film manufacturers were when they set out to conquer the disturbing results given by reticulation.

fig. 4

Sellotape lightly between two 6 x 6 cm cover glasses

Bas Relief

The Bas Relief is a combination of a black and white negative and its complementary positive slightly off-set and sandwiched between two pieces of glass. This sandwiched positive and negative is then enlarged and printed as a single element onto a sheet of bromide paper.

On Location

The subject to be photographed should have plenty of character – an old stone wall, a castle, a thatched cottage maybe; elderly men and women with strong well-defined features are particularly suitable for this technique. Strong shadows and bright highlights with plenty of graduated mid-tones should be aimed for.

Choose a day with strong sunlight, or at the very least it should be bright with high white cloud. Use a 35mm or a 2¼" (6 x 6cm) camera and run off a complete roll of 120 Tri-X or Plus-X or half a roll of 35mm film. Give yourself a variety of subjects from which to choose your final negative. Be accurate with the exposure using a meter and keep the speed of the shutter high avoiding camera movement at all costs to ensure sharp negatives.

In the Darkroom

Develop the Tri-X in Microdol-X (undiluted) for 10 minutes at 68°F/20°C. If you are using Plus-X reduce the development time to 7 minutes. Agitate for at least 15 seconds every minute to ensure even results; fix, wash for 10 minutes and then dry the film naturally in a dust-free area.

Make a set of contact prints and decide upon your best negative. The next stage will be to print this negative onto film to make a positive: a 35mm negative should be enlarged to about 2" wide, a 2¼" sq. negative should be printed in contact unless the image you need is too small, when it may also be enlarged.

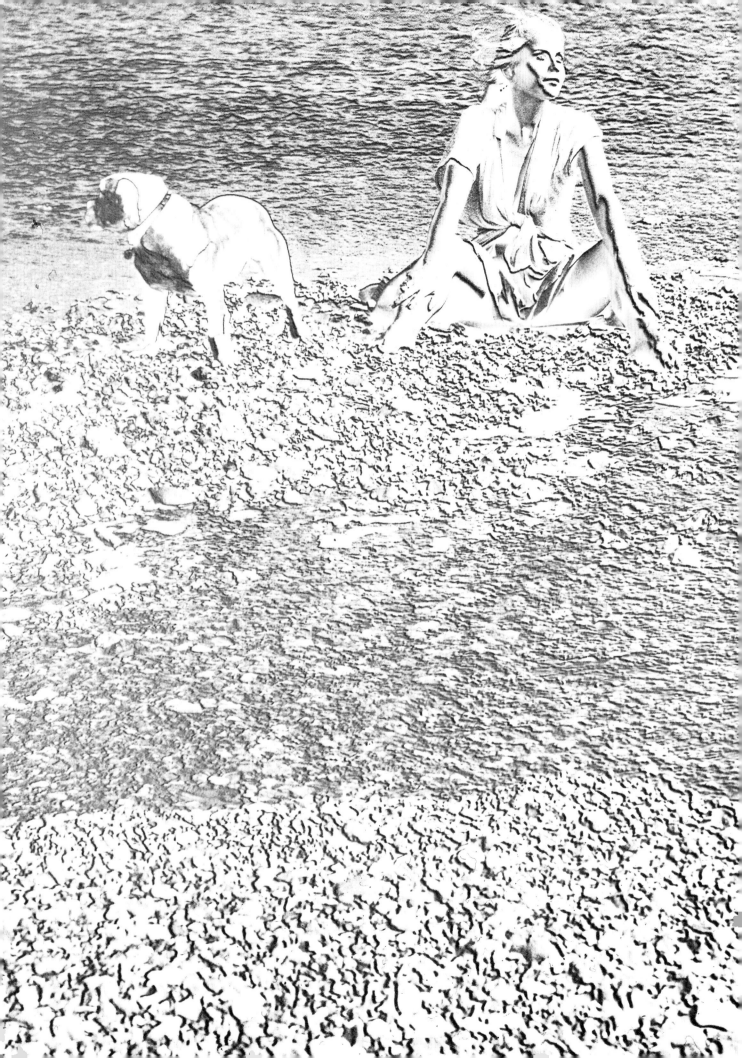

Change the darkroom safelight to red. Cut half a sheet of 5" x 4" Kodak Reproduction film 4566 and expose a test-strip as in fig. 1. Develop the test for 2 minutes in Kodak DPC print developer diluted 1: 9 at a temperature of 68°F/20°C. Fix, rinse and dry the test and view on a light-box. The test will show as a bright hard positive and you must select the most suitable exposure step and print the chosen exposure onto a complete sheet of 4566 5" x 4" film.

Check this complete 5" x 4" positive over a light-box. The highlights should be bright but but not too burnt out and the mid-tones should be even and well distributed. If the shadow detail is clogged, go back and check the test and choose the next step down. The positive does need good shadow detail.

Take the other half of the sheet of 4566 film and make a further test-strip (emulsion to emulsion) of the positive. Develop this test for 2 minutes in the DPC developer. This negative test should be a hard line negative with good strong blacks; however, it should not be as contrasty as a line conversion. This is the reason for using the DPC print developer. Choose a suitable exposure and then contact print (emulsion to emulsion) a complete sheet of 5" x 4" 4566. Develop as for the test, fix, wash for 5 minutes and dry. When both negative and positive are thoroughly dry proceed to the next stage.

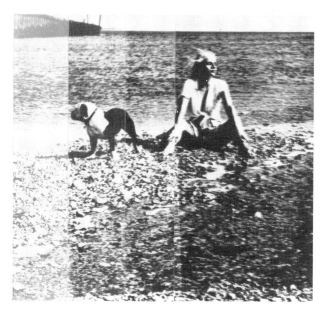

fig. 1 Positive test-strip 2, 4, 6 and 8 seconds

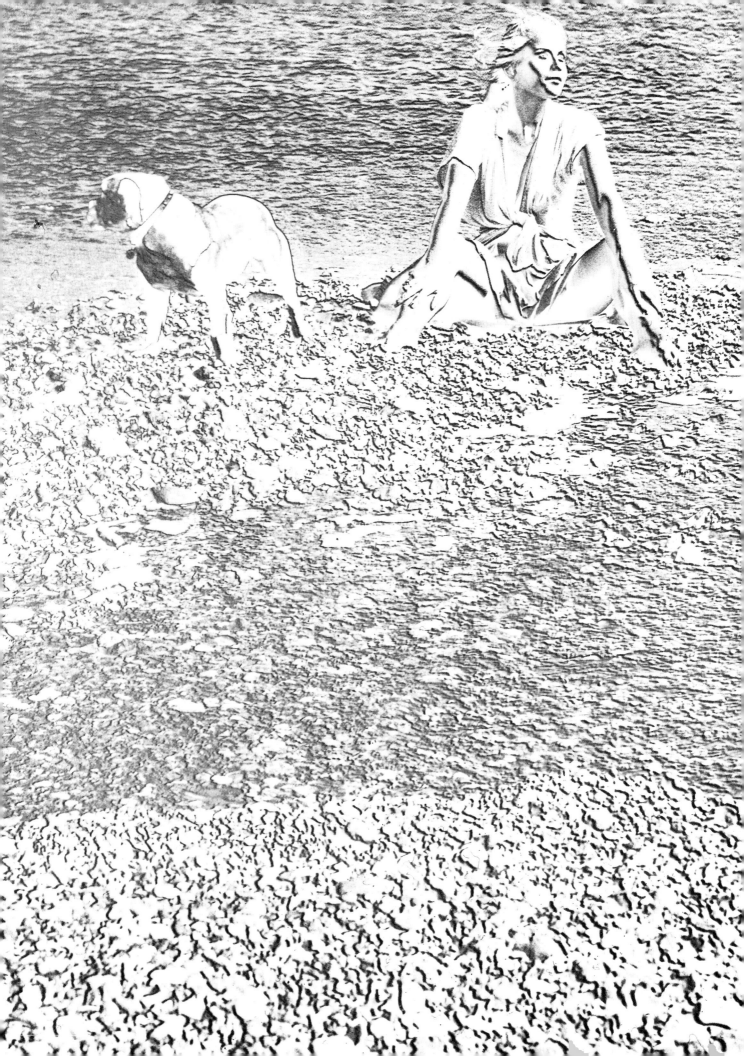

Change the darkroom safelight to red. Cut half a sheet of 5" x 4" Kodak Reproduction film 4566 and expose a test-strip as in fig. 1. Develop the test for 2 minutes in Kodak DPC print developer diluted 1 : 9 at a temperature of 68°F/20°C. Fix, rinse and dry the test and view on a light-box. The test will show as a bright hard positive and you must select the most suitable exposure step and print the chosen exposure onto a complete sheet of 4566 5" x 4" film.

Check this complete 5" x 4" positive over a light-box. The highlights should be bright but but not too burnt out and the mid-tones should be even and well distributed. If the shadow detail is clogged, go back and check the test and choose the next step down. The positive does need good shadow detail.

Take the other half of the sheet of 4566 film and make a further test-strip (emulsion to emulsion) of the positive. Develop this test for 2 minutes in the DPC developer. This negative test should be a hard line negative with good strong blacks; however, it should not be as contrasty as a line conversion. This is the reason for using the DPC print developer. Choose a suitable exposure and then contact print (emulsion to emulsion) a complete sheet of 5" x 4" 4566. Develop as for the test, fix, wash for 5 minutes and dry. When both negative and positive are thoroughly dry proceed to the next stage.

fig. 1 Positive test-strip 2, 4, 6 and 8 seconds

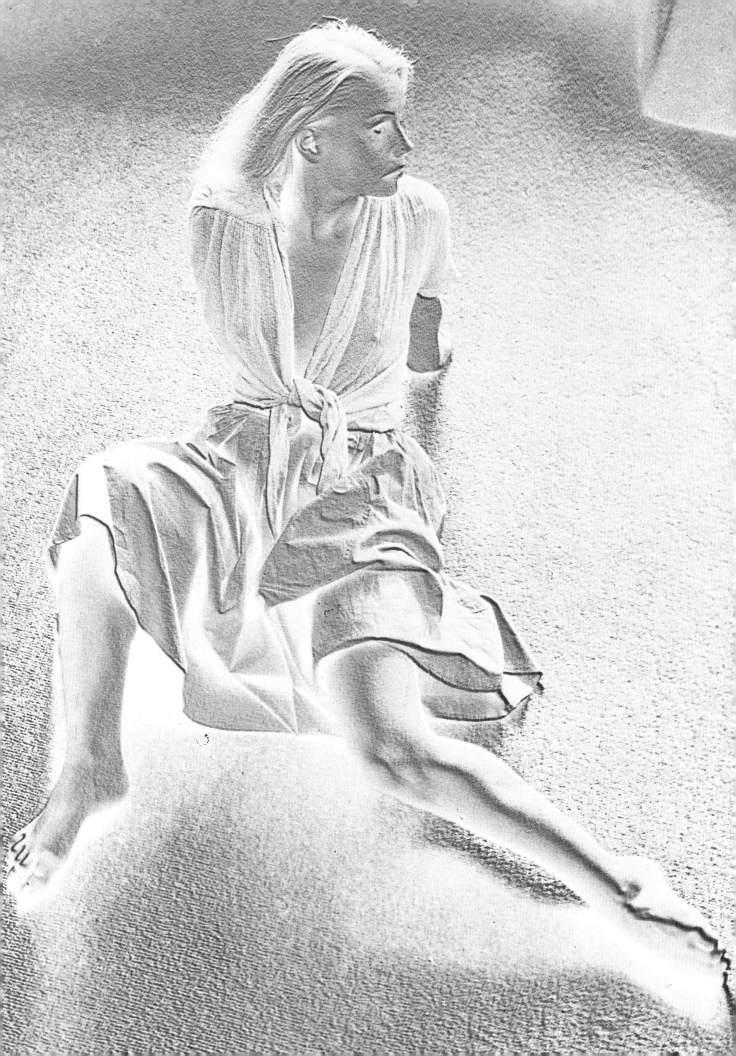

The Final Print

Take the positive and the negative to the light-box, making sure that it is clean, dry and dust-free. You now need two pieces of clean glass, preferably 5" x 4" or a size that your enlarger carrier will take (most miniature enlargers these days do not have glass in their carriers). Clean one of the glasses thoroughly and lightly tape the negative (the correct way round) to it. Then check the position of the negative in your enlarger without its carrier. Manoeuvre the negative on the glass until the image is in the correct position, i.e. central. Return to the light-box and tape the negative firmly to the glass making sure that dust has not been trapped between negative and glass. Take the positive and match it exactly on top of the negative. Then move the positive fractionally to the right or left until a fine white line appears around the image (fig. 2).

When you have chosen a suitable displacement between the positive and negative, place a clean weight on top and carefully Sellotape the two films together down one edge (fig. 3). Remove the weight and place the second sheet of glass on top, making sure again that dust has not been trapped between glass and film.

With the made-up carrier in the enlarger there will inevitably be light-spill when the enlarger is switched on, but this can readily be blanked-off by taping black card or paper around the carrier aperture (fig. 4).

Size the image up to 10" x 8" and expose a test on a normal grade of bromide paper, bearing in mind that the exposure will be at least two to three times longer than usual. Develop the print in DPC print developer for 2 minutes at 68°F/20°C. Fix, rinse and dry the test. You may have to expose a couple of tests to get the image looking right. Do not allow the blacks to spread over. Once satisfied with the test expose, develop, fix and wash a complete 10" x 8" print.

Try a couple of different prints. Move the top positive to a slightly different position each time. Every time the positive is moved, a different image is achieved.

The best results are achieved with only the smallest displacement, but it is surprising what a variety of images can be obtained just by moving the positive or negative sandwich in different directions.

fig. 2

Negative on the bottom

Move the top positive fractionally until 'white' line appears

fig. 3

When in position Sellotape firmly to glass

Made up glass carrier

fig. 4

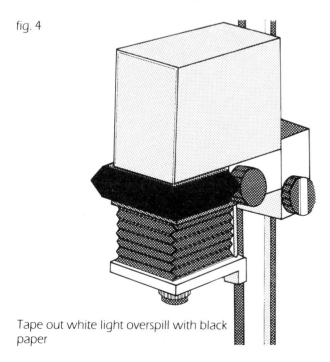

Tape out white light overspill with black paper

47

Negative Colour in Outline

negative

colour negative

positive fig. 1

This is a colour print on reversal paper (such as Kodak Ekta-chrome 14) but using a colour negative and a line positive, a technique which has to be used with some discretion. The important part of this experiment is that the line positive is printed with saturated colour filtration – in the example this shows clear blue – this colour can be selected entirely by the photographer and bears no relationship to the colours in the original photograph. It really is an effect photograph – the final result should have an air of mystery, so search out the un-usual to be photographed. If you are using a model, as illus-trated, keep the style of the photograph simple and straightforward, as a fussy and complicated shot does not suit this technique.

On Location

A large format camera such as a 2¼" sq. (6 x 6 cm) is prefera-ble, but a 35mm may also be used with success. Load the camera with Kodak Vericolor II professional film type S (6 x 6cm) or Kodacolor II film (35mm) and make at least a dozen exposures of your chosen subject. Choose a bright day for your photography and be accurate with your exposures, trust-ing to your exposure meter reading. The speed setting for Vericolor II is 125 and for Kodacolor II, 100. Keep the speeds of the camera high (1/125 second at least) or if you have to use a lower speed because of darker areas such as woodland make sure the camera is on a firm tripod to ensure that all move-ment is eliminated. A good sharp image will help in the later stages of the process. If you are photographing a landscape use a U.V. filter to cut haze in the distance and strengthen the tones of the sky.

In the Darkroom

Send the film to a reputable colour lab or process it in C-41 chemicals. From the colour negatives make a set of black and

white contacts – this will be quite adequate to show which frame to use.

Change the safelight to red for 5" x 4" Kodalith Ortho 4556 film, cut a sheet of film in half and make a test-strip in contact with the colour negative. Make sure the films are emulsion to emulsion to ensure maximum definition. You will find that the exposure with a colour negative is longer than that from black and white.

Have ready a small dish of Kodalith Super Liquid developer 1 part A to 1 part B to 3 parts water at a temperature of 68°F/20°C, and develop the test for 2¾ minutes, fix, rinse and dry. From your test choose the exposure with strong blacks in the shadows and good clear areas in the highlights.

Once you have assessed the exposure from the test expose a complete sheet of film and process as the test. When this positive is dry block out any dust spots with liquid opaque (fig. 1)

Place the colour negative in the enlarger carrier and size the negative up to 10" x 8" on the masking frame. Lock the enlarger and with a sharp pencil accurately trace the main shapes of the projected image on a sheet of A4 paper, which must be kept securely butted-up to the stops (fig. 2). Set the filtration recommended in the packet of Ektachrome 14 paper and stop down the enlarger.

Turn off all lights in the darkroom. Cut a sheet of 10" x 8" Ektachrome 14 paper in half and expose a test-strip, return the other half to its packet and place the exposed half in the rotary drum and close the lid. Turn on the white light and take the carrier to the light-box and replace the colour negative by the line positive. Set the carrier in the enlarger and check that the projected image matches the pencil outline exactly.

Decide upon a colour you would like the highlights in the final print taking into account the fact that the colour negative is predominantly orange and will print like this on Ektachrome 14. I chose blue for the result shown in the illustration and dialled in a filtration of 140 C; the filtration needs to be as high as possible to give you a good rich colour in the final print. Remember that here the filtration is not for colour balance and correction, but for density and graphic effect.

Turn out all lights and expose a further test-strip on the remaining half of the 10" x 8" sheet in the packet. Place this test alongside the first in the drum and process both tests together as per the manufacturer's instructions. Wash and dry the drum.

fig. 2

Trace down colour negative accurately

Dry the tests and view in a good light before doing the final print. Write on the back of each test the following information:

1) . . . Exposure
2) . . . Aperture
3) . . . Filtration
4) . . . Actual size of enlargement of negative/positive.

Check the exposure and filtration using the tests. If you think that the print from the colour negative needs to be 'warmer', add yellow: if 'colder', add blue. With the line positive, if you wish to get the highlights a richer colour, cut this exposure.

With the colour negative in the carrier realign it to the tracing on the baseboard and set the exposure and the filtration. Switch off the lights and expose a complete sheet of Ektachrome 14 paper and before you place it in the drum clip off the top right hand. Be extra careful not to move the masking frame. Expose the second image over the first and replace the paper in the rotary drum. Switch on the white light.

Replace the colour negative with the line positive in the enlarger carrier. Make sure that the projected image fits the tracing exactly. Check the filtration and the exposure assessed from the test-strip.

Turn out all the lights and take the Ektachrome 14 paper from the drum and place it in the masking frame making sure it is right up to the stops and that the clipped corner is still at the top righthand. Be extra careful not to move the masking frame. Expose the second image over the first and replace the paper in the rotary drum. Switch on the white light.

Process as per the manufacturer's instructions and agitate continuously to get even results. Wash the print for two minutes and dry. Wait until the print is completely dry before deciding whether the balance between the colour negative and the line positive is visually correct.

If the highlights are too rich, lengthen the exposure in the line positive stage or even try a different colour if the final print does not look right. It might well be worth trying to alter the colour of the negative stage by adding extra filtration. The final print needs an air of mystery. The colours should be complementary to each other but the weirder the final image, the better!

Half-Strength Sepia

Because it is so subjective I find this to be one of the most difficult of all the experiments. In the final analysis it comes down to split second timing and a personal judgement of what is, or is not, a good print. This cannot be taught or explained with any degree of accuracy.

After a number of experiments I found that a figure in the studio with controlled lighting the easiest method of achieving an acceptable result. The combination of the lighting of the figure, choosing the correct film, camera and the way that the film is processed appears to have a considerable bearing on the final result. However, a location photograph carefully selected can provide excellent results.

On Location

Choose a photographic subject that is soft and delicate showing à wide range of greys and has little, if any, harsh shadows. Think of misty dawns, delicate cobwebs, thistle-down. By all means use one of the modern soft-focus attachments but be careful to retain the maximum amount of definition. Against-the-light photography is ideal for this experiment but remember:
1)Against-the-light photography can be tricky.
2)The choice of film and the processing is important if you wish to avoid excessive grain.

When photographing against the light the automatic exposure meters on modern cameras tend to be inaccurate. Take two readings: the first, a general reading, the second, a reading of the shadow detail. Compromise by selecting the middle exposure. Photograph a number of different subjects to give yourself a wide choice.

My own choice was the studio portrait and this is how it was achieved:

Print from original
negative

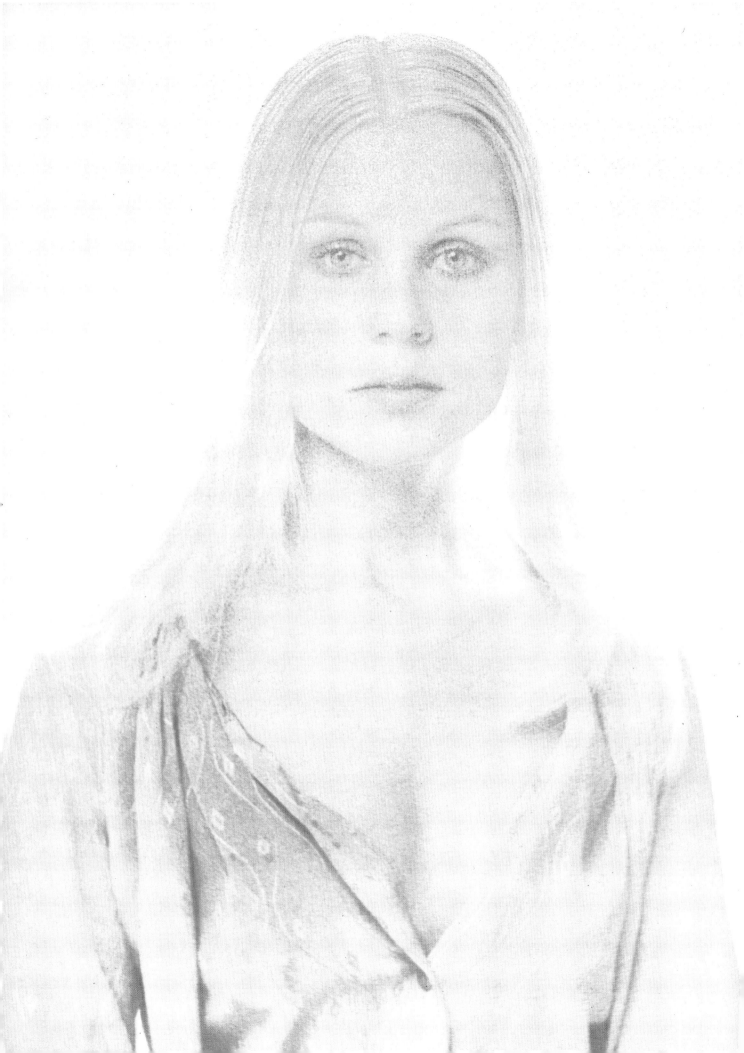

In the Studio

The model was requested to apply her make-up very flat, even the lipstick was powdered to prevent shine and too much contrast.

I chose a white background and seated the model about 1 ½ metres away: it was then lit by a spot, making sure that it fully covered the area I intended to use on the final print (fig. 1). This was done before any other light source was added. The sitter was then lit from one side by a diffused flood; it was high and tilted down at about 45° (fig. 2). A second diffused flood was then brought in from the opposite side until all the shadows were eliminated (fig. 3).

fig. 1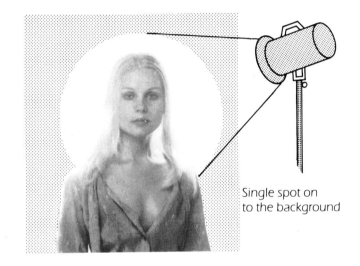

Single spot on to the background

fig. 2

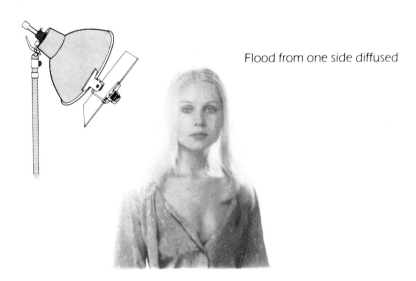

Flood from one side diffused

I made sure that the spot on the background was at least 1 ½ stops stronger than the two floods combined, again to eliminate the shadows caused by the floods. The model was moved closer to the background and the floods further away until the desired lighting balance was achieved.

To keep the face flat and even I decided to use Kodak Royal-X Pan 120 film and I rated it at 800 ISO/ASA, not 1250 ISO/ASA as recommended by the manufacturers. To make sure that my exposure was accurate, the spot was switched off and a meter reading was taken from the model's face (lit only by two floods). The camera was placed on a tripod and stopped down to *f*8. I was able to use a shutter speed of 1/60 of a second. Under artificial lights, models tend to get hot and eyes water so I made sure that my model was fully composed and her eye make-up still in good condition before firing the shutter. The complete roll was exposed to give a wide choice.

fig. 3

Flood from one side as main light (diffused)

Fill-in flood brought in until lighting is balanced (diffused)

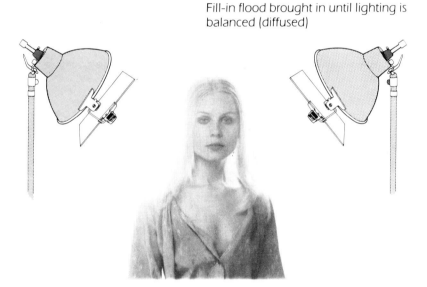

In the Darkroom

The Royal X Pan was carefully processed for 5 minutes in Kodak DK50 developer and agitated for 15 seconds every minute. A stop bath of 2% acetic acid was used to prevent dichroic fog that Royal X is prone to. It was fixed and then washed for 10 minutes.

Despite my precautions with the acetic acid, dichroic fog was present once the film was dry (it can be seen in the film rebates as a very slight grey and the rebates should be clear) so I decided to clear the veil with Farmers reducer.

Half a 5ml teaspoonful of potassium ferricyanide and a teaspoonful of hypo crystals were dissolved in 10" x 8" dish full of water at 68°F/20°C, this gave me a very weak solution of Farmers reducer. The film was then, with a see-saw action, carefully bleached until the offending dichroic fog dispersed (fig. 4). The solution of Farmers must be very weak and used with discretion: too much bleaching and the shadow detail can be lost; the negatives can also become streaked and uneven. The film was re-washed for 10 minutes, a spot of wetting agent added to the final wash and it was then left to dry naturally in a dust-free area.

Because of the excessive flooding on the background (caused by the spot) my negatives looked very flat with hardly any shadow detail at all. This was deliberate and I suggest you aim to achieve the same result for this particular experiment. A set of contacts was made and a suitable frame selected.

I made a test-strip on Kodak grade 1 paper across the face, ignoring the background and edges of the figure completely. It was deliberately kept soft and delicate, the blacks are not im-

Fig. 4

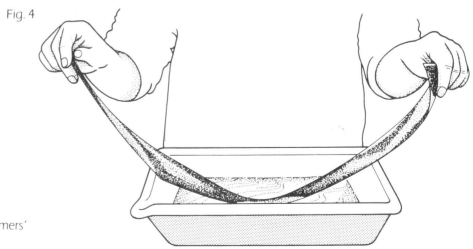

See-saw film through weak 'Farmers' solution

portant but the white highlights were kept clean and the half-tones even. This test was fully developed for 2½ minutes in Kodak DPC print developer diluted 1:9 at 68°F/20°C. This is important – if the print is not fully developed streaks and marks can occur in the final sepia toning process.

Once the exposure had been assessed from the test I exposed a complete 10" x 8", developed as the test and fixed it. I washed it thoroughly for 20 minutes to make sure all traces of hypo were eliminated.

The final step was to sepia tone the print in stages to achieve the half-strength sepia.

A solution of bleach was made up, viz: 4 teaspoons of potassium ferricyanide to 1 teaspoonful of potassium bromide (the plastic teaspoon is kept just for this purpose): they were dissolved in 20oz. of water at 68°F.

The print was placed in a 10" x 8" dish and bleached until the image disappeared (fig. 5), it was then rinsed until the yellow staining dispersed.

A second dish (10" x 8") of re-developer (sodium sulphide) was prepared. This re-developer was a very weak solution. My sulphide is in flakes and I dissolved just half a flake (about ½" square) in 20 oz. of water at 68°F. The print was re-developed in stages:

15 seconds in the re-developer (fig. 6) and then rinsed and inspected (fig. 7); 15 seconds more and a further rinse. The procedure was continued until the strength of the sepia-toning was judged correct; it was then fixed.

Sometimes even this weak solution can give too stong a result. In this case the solution can be made even weaker; the re-develop/rinse stages can then be further extended.

The final print was washed for ten minutes before drying and mounting on card.

fig.5

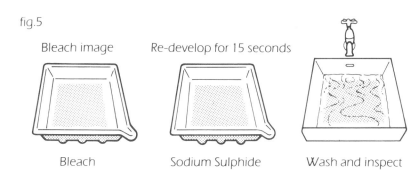

| Bleach image | Re-develop for 15 seconds | |
| Bleach | Sodium Sulphide | Wash and inspect |

Solarized Image

The discovery of the solarized image, like that of plastics, was a laboratory accident; in this instance the accidental switching on of a light fogging the emulsion during development. Quite simply a negative whilst being developed is exposed for a brief time to white light and then is allowed to continue to develop for a short time before being fixed. The result is a positive/negative that can be printed giving a strange and often attractive photograph. It is not, however, an easy thing to achieve deliberately and may well involve a number of frustrating failures before a successful and pleasing image is realised. This experiment shows how the process and procedures can be controlled, to some extent, by introducing intermediate stages. In short, instead of trying to solarize the original smaller negatives of 35mm and 2¼" sq. (very risky if you have spent a great deal of time on location setting up the shot), they are printed onto other larger film stock for the solarizing process.

On Location or in the Studio

Almost any subject can be photographed but the human figure works very well and has produced excellent results over the years.

Take your favourite model on location or set up a studio shot using the figure at full length and lit with a strong key light plus a fill-in for modelling. The modelling is important, the more depth and form the figure has the more spectacular the final result. Strong lighting also applies when on location, so choose a day that is clear and bright. The figure must have good tonal greys throughout; if they are right, the solarization process will enhance them.

Using a 35mm or a 2¼" sq. (6 x 6cm) camera loaded with Tri-X or Plus-X film and ensuring accurate metered exposures, whether on location or in the studio, run off a complete roll of film on just one subject.

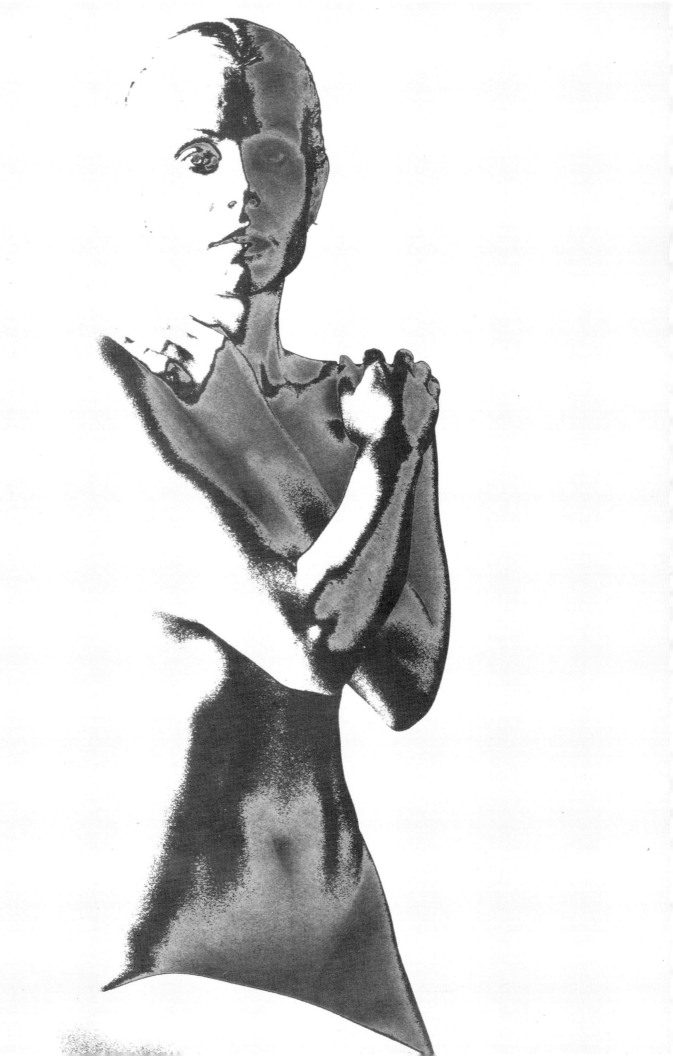

In the Darkroom

Tri-X film should be developed for 10 minutes in Microdol-X developer (undiluted) at 68°F/20°C and Plus-X for 7 minutes. Agitate 15 seconds every minute to ensure even results; fix, wash for 10 minutes and dry the film naturally.

Make a set of black and white contacts and select a frame. Change the safelight to red and pour out a small dish of Kodalith Super Liquid developer, 1 part A, 1 part B to 3 parts water at a temperature of 68°F/20°C. Take the selected negative and, if 35mm, place it in the carrier and enlarge to 2" wide; if 2¼" sq. (6 x 6cm) make a contact. Note, however, that the larger the image at this stage the better, so if you are lucky enough to have a 5" x 4" enlarger make the image as large as possible within 5" x 4".

Expose a test-strip onto half a sheet of 5" x 4" Kodalith Ortho film 4556. The development time is 2¾ minutes and after fixing, rinsing and drying, the test image will show a bright hard positive.

Choose a suitable exposure from the test and expose a complete sheet of 5" x 4" Kodalith 4556 at this exposure.

Place the film in the dish of developer emulsion side up and rock the dish gently. After about a minute the image will begin to appear. As soon as the shadows (black areas, this being a positive) begin to thicken-up switch on the white light for about 3 seconds. (The time depends on the power of the light source and its distance from the dish and it will only be established by trial and error.) Alternatively use a flash bounced off the ceiling (fig. 1b).

fig. 1

Red light

Film emulsion up

a

Develop for 1 minute (approx)

b

Switch white light on for 3 seconds or
bounce flash off ceiling

c

Develop with the emulsion side down
until the highlights begin to fog over
then fix

d

fix

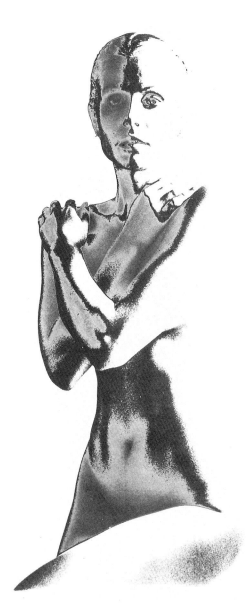

Turn the film over so that it is emulsion side down. The high-light areas, i.e. the white areas, will now begin to fill-in or fog over. The secret is to get the film into the fix before the fogging in the highlight detail completely blanks out the film. You will probably need one or two attempts to get this stage correct. Time the three stages very carefully in your own conditions. First the initial development, then the white light exposure time, and finally the development time after the white light has been switched on and off. Fix the film, which is now a positive/negative for 3 minutes. It is always important when transferring a developed film from the developer to the fix to agitate it thoroughly. In this particular case make absolutely certain that fixing is quick and thorough, it will prevent air bubbles forming and developing marks occurring. Wash for 5 minutes and then dry.

You can now print this film (positive/negative) straight onto a sheet of bromide paper or, as in the case of the illustration, re-verse the image to what I call a negative/positive; this is the way I prefer working:-

Take the positive/negative and make a contact test-strip onto half a sheet of Kodalith 4556 film and process it in Kodak DPC print developer for 2¾ minutes at 68°F/20°C. Fix, rinse and dry the test. Assess the exposure and then contact and process a complete sheet of 5" x 4" Kodalith 4556 film (fig. 2). Ensure when contacting the two films that all surfaces are scrupul-ously clean and free of dust. (Being a lith film Kodalith Pan 4556 film is notorious for emphasising dust and marks). Wash for 5 minutes and dry.

Set the masking frame to 10" x 8" and expose a test-strip on a normal grade of paper; then develop for 2 minutes in DPC print developer at 68°F/20°C. Assess the exposure from the test and expose a complete bromide print. Do it without dodging; if the intermediate tones fill-in print on a softer grade of paper. Your result should, as in the example, show the two tone areas separated by a thin black line to give the characteristic solarized image. The mid-tones should be defi-nite and in sharp contrast.

fig. 2

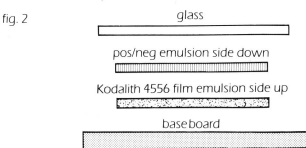

glass

pos/neg emulsion side down

Kodalith 4556 film emulsion side up

baseboard

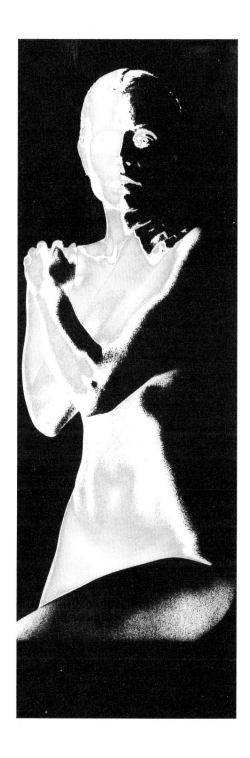

Double Exposure in Colour

This is a colour print using two transparencies double-printed onto Kodak Ektachrome 14 paper.

One is of the main subject, a figure, say, and must be photographed against black. The other is of the background and must have black areas where the main subject is to show.

The photographic subject matter is unlimited. My own result consists of three main parts, and was achieved as follows:-

Part 1 – The Background

The word "background" is not strictly true for this particular experiment and I only use it (for want of a better word) to help explain the procedure. This part of the experiment is an integral and important part of the whole, as in many ways it dictates the outcome of the final print, so it should be given some considerable thought.

My objective was to get a colour transparency with a 'bubbled' effect and I achieved this by subjecting it to varying intensities of heat (without destroying the transparency completely). I found that the larger the image, the easier the procedure was to control.

A 2¼"sq. (6 x 6cm) camera was used; it can, however be successfully achieved on 35mm.

A piece of foil from a kitchen roll was draped from wall to table as in the diagram (fig. 1) and then further pieces of foil from old cigarette cartons etc. were crumpled into random shapes and piled on top of this. Two floods were set up – one on either side – and tilted down at about 45° to the subject, one with yellow gelatine across the front and one with red. I made sure that the gelatines were supported on double bulldog clips away from the reflectors and bulbs to prevent them melting under the heat of the lamps (fig. 2). Coloured gelatines were obtained from a theatrical lighting supplier,

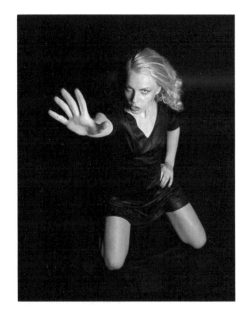

Original photograph

Melted 2¼ square transparency

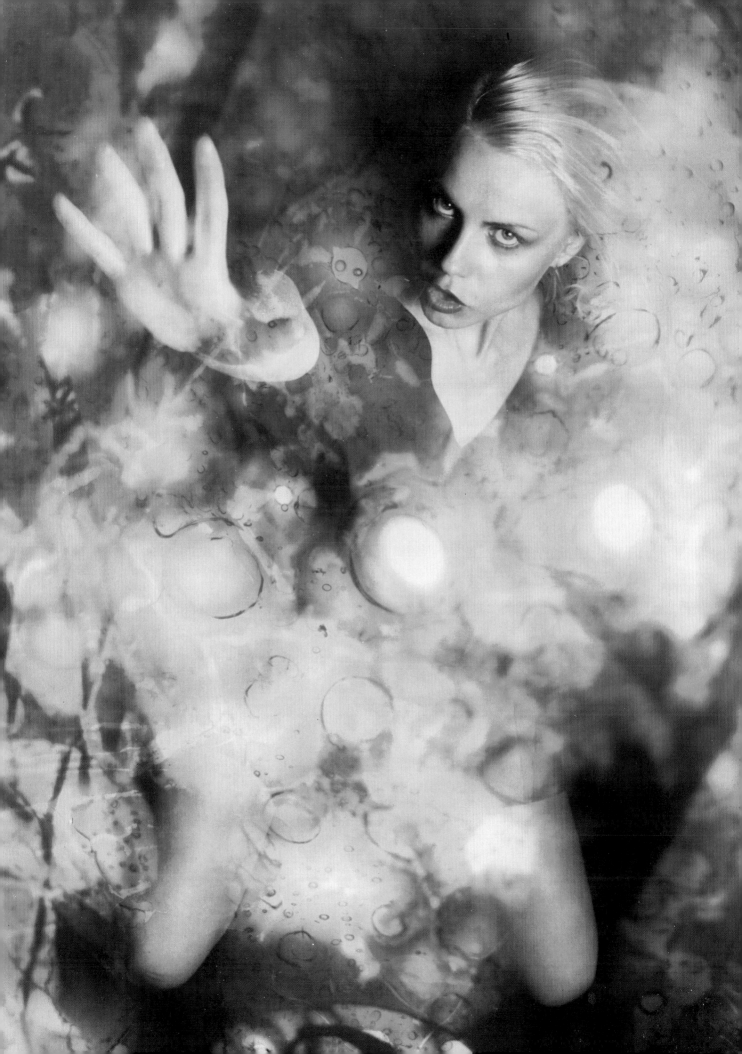

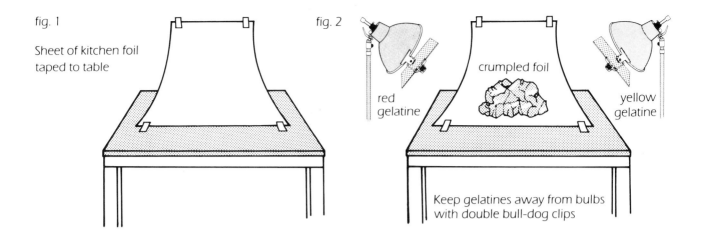

fig. 1

Sheet of kitchen foil taped to table

fig. 2

red gelatine

crumpled foil

yellow gelatine

Keep gelatines away from bulbs with double bull-dog clips

fig. 3

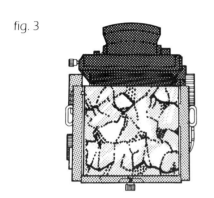

Fill screen with crumpled foil

fig. 4

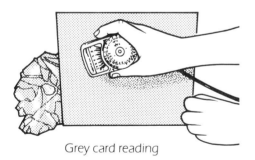

Grey card reading

but other coloured gelatines or Cellophane could be used. If you have difficulty locating gelatines, use coloured foil combined with coloured filters in front of the lens.

I used Kodak Ektachrome 50 Professional film (tungsten) and set up the camera so that the image of the foil more than filled the screen (fig. 3). No attempt was made to get a completely sharp picture, simply interesting shapes to make a pleasing abstract design.

A meter reading was taken, but be warned: when photographing any highly reflective surfaces or material the meter tends to read out much higher than usual and dense transparencies (underexposed) are usually the result. In conditions such as these I take a grey card reading and bracket the exposure.

The grey card is held immediately in front of the subject and a meter reading is taken of its surface (fig. 4); this exposure can be taken to be correct. When I bracket this it is a whole stop either side of the standard reading, viz: the meter on this particular set-up read out at 1/30 at $f8$ so I opened up the aperture to $f5.6$ and closed it down to $f11$, thus giving me three readings in all. The 'wrong' exposures came in useful later on.

A complete roll of Ektachrome 120 was exposed giving me a varied choice of backgrounds, and it was sent to a reputable colour lab handling E-6. You can process the film yourself using Process E-6. chemicals.

When the transparencies returned, the least appealing was chosen for a test. It was mounted in a metal slide mount (although plastic could be used) with the glass removed, and holding this with a pair of pliers I heated the transparency gently over a candle flame, the candle being placed in a

saucer on a light-box (fig. 5). After a few seconds the transparency began to melt and as soon as it began to bubble it was quickly moved away. It took two or three attempts to get right and this is where the wrongly exposed transparencies came in so useful: I used them to test the timing.

I also found another minor problem occurring: the transparency acquired a deposit of soot so that the full extent of the bubbling could not be seen, it therefore had to be rewashed to realise the whole effect. It was also found that a transparency that had partially melted away was usable (fig. 6), it was simply restored to its original 2½″ sq. with black masking tape (fig. 7).

I set the masking frame to give a ¼″ rebate on a 10″ x 8″ and enlarged the transparency to give a pleasing abstract shape. Note however that the transparency, because of the heating, is bound to be buckled. I taped mine to the carrier with black masking tape, ensuring that all white light that might get through to the baseboard was blanked out.

A piece of white paper (A4) was taped to the baseboard of the masking frame right up to the stops. With a sharp pencil the projected main shapes were carefully traced and then shaded in the black or very dark areas (fig. 8). A note was made of their colours and their rough positions and the top was clearly marked. This sheet of paper was immediately filed along with the transparency.

Part 2 – The Figure

My next task was to fit a figure into the background. By using the tracing it helped to get an idea for posing the model. Her pose was dictated to some extent by the black areas, but I knew these black areas could be extended somewhat on the final print so I only used the tracing as a guide. Careful note was taken of the yellow areas on the background trace so that they would eventually merge with the blond hair of my sitter on the final print. I also decided that the bubbling effect ought to show through the body so I requested my sitter to wear a black dress.

To isolate my model completely I used a black background and it was in fact a large piece of matt black material that 'soaked-up' the light. You do not, however, have to go to such expense if you do not intend to do a lot of studio-style photography. The cheapest method is to paint a wall matt black and place a sheet of hardboard on the floor and paint that black also. If you find it difficult to arrange an indoor studio session

fig. 5

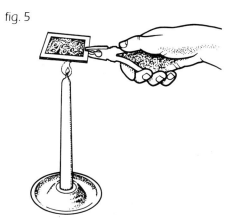

Hold transparency with pliers (gentle heat)

fig. 6

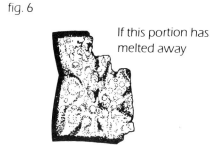

If this portion has melted away

Make up with black tape to original 2¼ size

fig. 7

with such a large black area, try a night shot outside using a flashgun. The lighting may well be harsh but as long as the figure has action, harsh shadows and bright highlights are quite acceptable for this particular experiment.

With my own studio shot I decided to make it an action one, too, so I used my large flash unit with a diffuser. It was kept high and pointed down at about 45° and I made sure that the lighting covered the whole of the figure and was not too close to cause a hot-spot. During the course of the shooting session regular checks were kept on the background tracing to make sure that the figure would complement the shapes and colours already achieved. Two rolls of Extachrome 64 (daylight) were exposed to precisely the meter reading given me by the meter designed for my particular unit. They were then sent off to the colour labs.

The processed transparencies had minor visual faults. The black dress and parts of the background had caught the light, so with a fine sable brush, black spotting dye and using a linen-tester on a light-box the faults were retouched back to black (fig. 9).

fig. 8

fig. 9

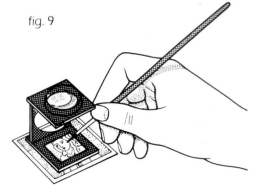

Retouch with a linen-tester or magnifying glass on a light-box

The retouching was done on the emulsion side and great care was taken to keep fingermarks off the figure. When the retouching dye was dry I filed it with the background transparency and the tracing.

Part 3 – The Double Print

The final task was to print the background transparency first onto R14 paper and then that of the figure.

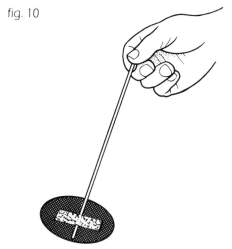

fig. 10

I could see from my tracing that the figure would not fit into the black areas exactly so I decided to hold back the area where the legs were to print with the two fingers of my right hand, and with a made-up dodger (fig. 10) I could hold back the area where the head would print. The hand and arm fell conveniently into a dark space. (Obviously your figure will be different so you will have to devise your own masking device).

The background tracing was re-Sellotaped onto the masking frame up to the stops and the figure transparency enlarged to fit within the background shapes: then with the enlarger locked, the projected image was carefully traced down with a blue fibre-tipped pen (fig. 11).

1¾" oval cut from black card

With the positions of both transparencies decided upon and accurately traced I made a test-strip of each.

The figure transparency was in position so I dialled in 35Y as recommended by the manufacturers on the packet of R14 paper, stopped down to *f*8, turned out the white light, took out a sheet of paper, cut it in half and exposed a step test on one half and placed it in the rotary drum; the other half was returned to its packet.

The background was treated in the same manner, re-enlarged up to the tracing, stopped down to *f*8, 35Y dialled-in and the other half of the sheet used and step-tested, then placed alongside the first test in the drum. These were processed together with fresh chemicals exactly to the manufacturer's instructions and dried before assessing the exposure and colour balance.

Before making my final exposures I checked that the dodger and a pair of scissors were handy and memorised their positions.

The background transparency, still in the enlarger, had to be exposed first, but – with the safelight on – I decided to practise holding back with the dodger and my two fingers the areas where the head and the legs would finally print. (These could now be more accurately assessed because of the blue pen trace.) They were moved slightly up and down to achieve a merging effect of figure and background on the final print (fig. 12).

fig. 11

Mark up figure transparency in blue
Pentel

I changed the filtration to 30Y and decided upon a 20- second exposure, both assessed from the test. With the dodger in my left hand the white light was switched out. A sheet of Ekta-chrome 14 paper was placed in the masking frame and with the dodger and right hand roughly in position the enlarger was switched on with the foot switch. The trick was to get the dodger and the fingers into position as quickly as possible to prevent exposure onto the selected areas of the face and legs. This operation is obviously much easier if you have a foot switch; if not the dodger will have to be placed on the baseboard in position and when the enlarger is switched on it will have to be picked-up quickly and moved up and down to ensure that the merging effect is achieved.

Before the exposed paper was placed in the rotary drum, the top right-hand corner was clipped off with scissors; (this is to make sure there is a check for putting the paper in the frame the correct way round for the second exposure).

With the paper safely in the drum and the paper packet closed, the white light was switched on and the background transparency replaced by the figure transparency. This was re-sized up to the tracing (blue pen outline) and stopped down to f8. The exposure (15 secs.) and the filtration (30Y) were as-sessed from the test.

With the white light out the exposed sheet of paper was taken from the drum and placed in the masking-frame, mak-ing absolutely sure that the cut corner was in the top right-hand corner. Great care was taken not to move the masking frame and to see that the paper was square to the stops of the masking frame.

The second exposure was made, the paper returned to the drum, the lid closed, and the white light turned on.

Fresh chemicals were poured out and brought up to temperature and the print was processed as the tests. I waited until the print was dry before checking the exposure and the colour balance.

I found it important that the background did not overpower the figure and the predominance of yellow was not reflected in the skin tones of my model.

The merging of the figure into the background was critical to the balance of the print as a whole; in fact I had two more attempts at getting this merging correct. The photographed hand worked quite well as it fell conveniently into a dark area but the legs and head were more difficult and they were improved upon by moving the dodger and my fingers up and down more frequently during the first exposure.

For me this merging is most important; it gives the print that little bit extra over the double-exposed transparency, or negative. It is not so random and with practice and patience the two transparencies can be merged with great precision.

fig. 12

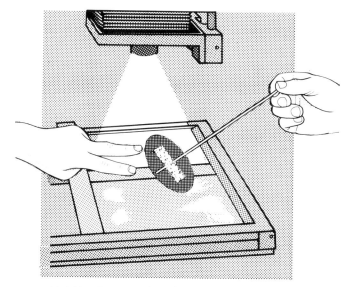

Hold back areas where legs and head
will print

Emphasised Grain

This kind of print in which the grain of the developed negative is allowed to show, giving strength and character to a suitable image can, with new technology, be achieved by a process engraver adding a screen to a line negative/positive. However, by using the following photographic method the final print does not look so mechanical, and by altering the size of the image on the negative, the dot size – which is the product of the graininess of the film – can be controlled to some extent.

Because the grain-produced dots need so much emphasis in the final print, the most important element of the whole process is the choice of film: Kodak Royal-X Pan or Recording Film 2475. If you have a 2¼" sq. (6 x 6 cm) camera use Royal-X Pan; with a 35mm you require Recording Film 2475. Note that Recording Film is not usually held by a local stockist so you may well have to apply to a main dealer or to Kodak direct. Royal-X Pan is more widely available but usually only main dealers hold stocks in any quantity.

To emphasise the dot further two more stages are introduced in the darkroom. The original negative is contacted onto line film to produce a bright positive and a further line negative is made from that.

This process suits portraits and strong, moody landscapes. If you choose a landscape use filters to enhance the sky, viz: if it is cloudy use an orange filter, if it is bright blue use a red.

My choice was the portrait and I suggest you approach it thus:-

In the Studio

Use a white background and make sure it covers the head and shoulders adequately: a white projection screen is the ideal size. The sitter should be seated 1 to 1½ metres away. Her make-up should be flat with just a touch of rouge and the

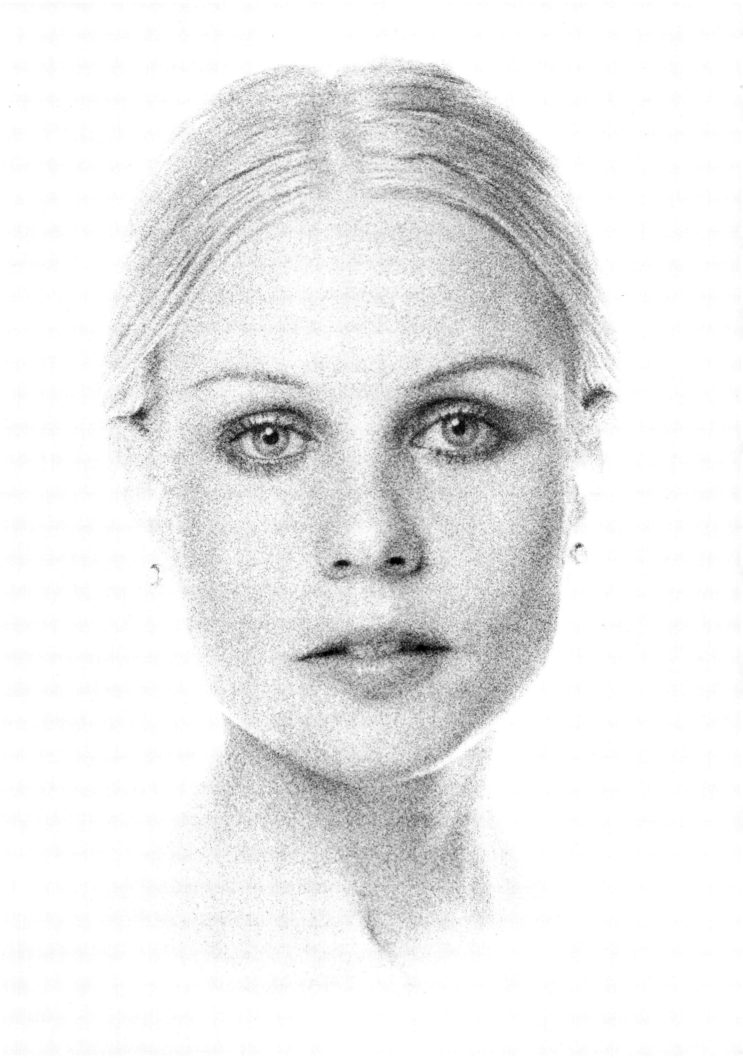

fig. 1

fig. 2

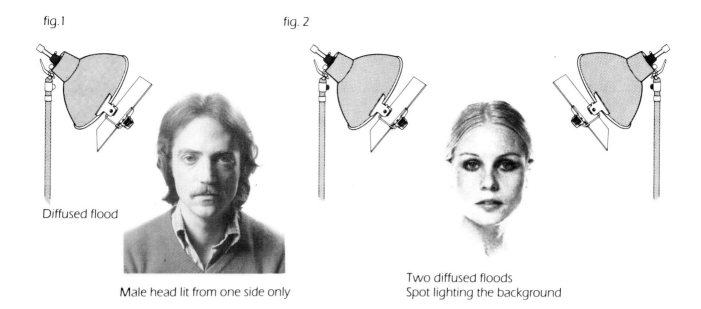

Diffused flood

Male head lit from one side only

Two diffused floods
Spot lighting the background

lipstick must be toned down and have a matt finish; keep eye-shadow heavier than is usual for everyday wear.

A bare neck and shoulders helps with the final print so request the model to wear a strapless bikini top.

Lighting

With a female model avoid harsh shadows and use two diffused floods. If you use flash make sure the two units are fitted with umbrellas to keep the lighting on the face soft and even. With the male sitter just one diffused flood high up and pointed down at 45° from one side is very effective (fig. 1).

Once the lighting on the front of your model is to your liking, add a further flood or spot to the background to make it clean, white and even; also make sure the background lighting kills the shadows cast by the main floods, this will help with the final print (fig. 1)

Camera

The choice of camera and the size of the image on the ground glass screen (or in the viewfinder) is crucial to the final result.

If you are using 2¼"sq. (6 x 6cm) make the depth of the head no more than 1¼ inches deep, this will increase the grain. If you use 35mm the whole of the film area can be used. On location with the 2¼"sq. camera the actual scene required on the final print must also of course be no more than 1¼" wide/deep on the ground glass screen (fig. 3).

fig. 3

Image required on final print to be no more than 1¼" within 2¼" square

Exposure

Royal-X film is rated at 1250 ISO/ASA and Recording Film 2475 at 800 ISO/ASA. They are very fast emulsions and if developed as per the maker's instructions will achieve these speeds; however, we need to process differently to achieve our ends so I re-rated the Royal-X Pan film to 800 ISO/ASA. As always use as exposure meter and be accurate.

In the Darkroom

To increase the grain, instead of processing in fine-grain developer (recommended by Kodak), develop in Kodak DPC print developer diluted 1 to 9 at a temperature of 68°F/20°C with continuous agitation for 2½ minutes – streaks and unevenness may well occur if the tank is allowed to stand for more than 15 seconds. It should be noted that the manufacturers do not recommend this type of development; however it does achieve the result I am after. Use a stop bath of acetic acid diluted to 2%. This will help prevent dichroic fog that Royal-X is prone to. Fix, and wash for 10 minutes, then add a spot of wetting agent to the final wash and hang the negatives up to dry naturally.

Royal-X has a softer emulsion when drying than that of Tri-X or Plus-X so be careful not to scratch or mark it. The processed negative should be about 20% denser than normal but not too contrasty.

Print a set of contacts and select a frame.

The Positive/Negative stage

Make a positive test-strip contact from your chosen negative by using a half sheet of 5" x 4" Kodak Reproduction film 4566 (it is contacted to retain maximum definition).

Develop for 2 minutes in Kodak DPC print developer diluted 1 to 9 at 68°F, *not* the Super-Liquid, and this will give you a bright, hard positive. Fix, rinse and dry the test.

Check the test over a light-box to assess the size of the dot; use a magnifying glass or a linen-tester. If you are unable to judge from the positive test the size of dot you require, put the test in the enlarger and do a negative print to the size of the final print required, (i.e. 10" x 8"). Only experience can really tell you what is a suitable size of dot for any given photographic subject. It is a very personal choice. If you wish the dot to be larger you will have to go back and reshoot the model, (i.e. instead

of the head being 1¼" deep, reduce the image to ¾". If you require the dot to be smaller, photograph the image of the head larger, to 1¾" or 2" deep. (Note however, that with 35mm the dot cannot so readily be made smaller as the maximum depth obtainable is obviously only 1½").

Once you have decided upon the size of the image (and therefore the dot), assess the test for exposure.

The objective, despite reducing the positive to semi-line, is to retain as many dots in the highlights as possible. Choose the step on the test that has not burnt-out the highlights, (i.e. over-exposed); but also be careful not to choose an under-exposed step; the dot in the shadows should still be present.

To get the positive correct is quite tricky; I have noticed that just the slightest change of conditions such as half a minute too long in the original developer or a location shot on a bright day with harsh lighting, causing hard negatives, can have a radical effect on the intermediate stage positive.

Once the exposure is assessed, expose a complete sheet of 5" x 4" Reproduction 4566 film by contact and develop as the test. Fix, wash for 3 minutes and dry.

Make a line negative from the positive; it must not be as contrasty as a line conversion, so the DPC print developer must still be used.

Contact the other half of the 5" x 4" 4566 film as a test and develop for 2 minutes at 68°F. Fix, rinse and dry. This negative test should have a full black dot; however it requires careful checking.

As with the positive try to retain as many dots as possible. Obviously because you are using a line film, highlight areas are bound to clog and some shadow detail will be lost completely, but the more evenly distributed the dot becomes throughout the highlights and the shadow detail the more successful the final print.

Once the exposure is assessed, expose and process a complete sheet of 5" x 4" 4566 film as the test. Fix, wash for 3 minutes and dry.

Enlarge this final negative so that it is about 7½ inches deep within a 10" x 8". The base of the image needs to be vignetted, (this is where the bare neck and shoulders are so useful). This particular style of head shot does require a fair amount of white area all around to give it impact.

To achieve the vignette effect at the base of the print is fairly straightforward. Simply move a piece of matt black card between the lens and baseboard whilst exposing the print (fig. 4). You must, however, start with the mask in position before the enlarger is switched on. It must be moved slightly to and fro during the whole length of the exposure to ensure this soft edge.

Do not be tempted to print the negative on a hard grade paper just because it is a line negative; it is much better to begin on grade 3 paper and, if necessary, drop down to grade 2. In fact treat the print as a continuous tone.

Develop, fix, wash and dry the print and then mount on card.

Finishing the Print

If, despite the precautions taken with the intermediate stages the dot is not continuous throughout the highlights and shadow areas you will have to retouch discreetly with a fine sable brush and spotting dye. However, the retouching of an emphasized grain print requires a great deal of skill. The emphasis should be on having to do as little as possible by way of retouching or the result will look artificial and not photographic – the aim of the experiment.

fig. 4

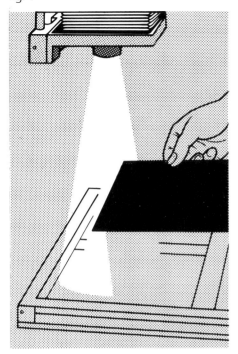

Soften shoulders and neck with matt black card

Photographic Mosaic

The variations of shape and colour that can be achieved with this procedure are so numerous that it is one of the most spectacular experiments in the darkroom. From an original black and white tone negative of one's chosen subject three line positives are made, two of them through suitable screens, the third is left unscreened.

From this unscreened positive a line negative is made. The 'family tree' diagram (fig. 1) helps to explain the procedure.

These components are then printed in a variety of combinations, using colour filters, on to Ektachrome 14 direct reversal paper, as will be explained under the heading 'In The Darkroom'.

Just changing a single colour or screen radically alters the whole look of the print. Once you have a successful result, the temptation is to go on and produce many varied images; the choice of arrangement of the different elements – the negatives, positives, screens and colours – is endless.

For maximum flexibility a studio shot with a white background is advisable and a human figure (male or female) works well. Landscapes initially need to be simple as they can finally become very complex, but if chosen with care they can be extremely effective. I chose the figure in the studio, and adopted the following method:-

In the Studio

You need a white background, a painted wall or a white projection screen will suffice. The figure needs to be lit from one side with either a spot or a flood, without a fill-in. This is essential; the figure needs large areas of shadow so keep the light well to one side as in fig. 2. Light the background with a further lamp making sure that it kills the cast shadow and covers the whole of the figure as in fig. 3.

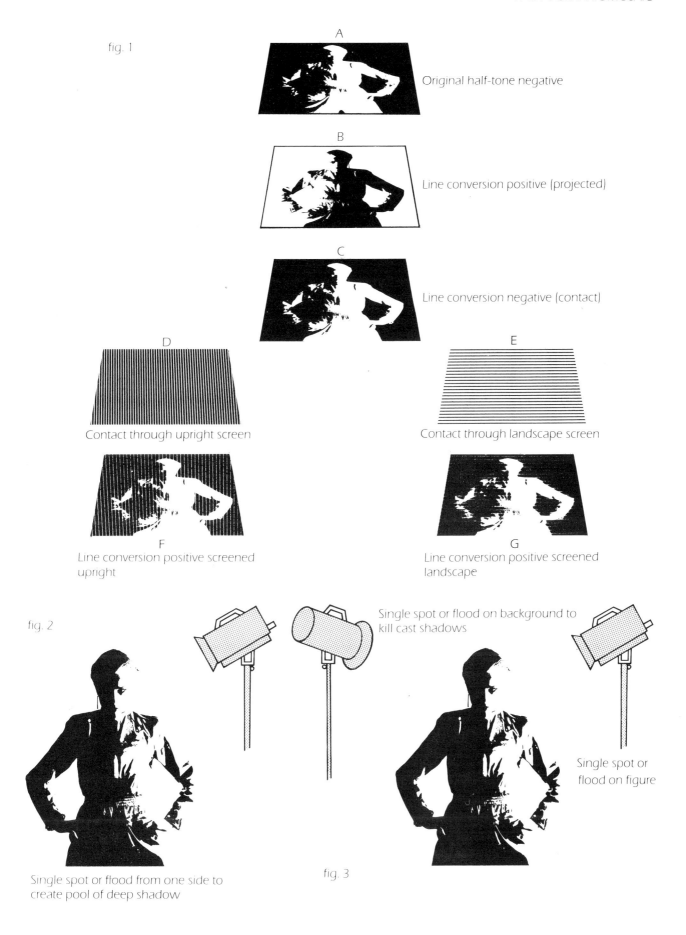

fig. 1

A

Original half-tone negative

B

Line conversion positive (projected)

C

Line conversion negative (contact)

D

Contact through upright screen

E

Contact through landscape screen

F

Line conversion positive screened upright

G

Line conversion positive screened landscape

fig. 2

Single spot or flood on background to kill cast shadows

Single spot or flood on figure

Single spot or flood from one side to create pool of deep shadow

fig. 3

Film and Exposure

Load a camera (2¼" sq. 6 x 6cm or 35mm) with Kodak Tri-X or Plus-X film.

Be careful with the exposure. Once the lighting is to your satisfaction, turn off the background light and take a meter reading of the highlights, then the shadows; use the average of the two readings. If you have a 35mm camera with a through-the-lens meter, give the exposure of the read-out plus a second exposure at least one stop open on the L.E.D. display, i.e. if the exposure reads out at 1/30 at ƒ8 expose for this and also open up to a 1/30 at ƒ5.6; alternatively, if you need the stop at ƒ8 to get an adequate depth of field, use the slower speed of a 1/15. At these slow speeds make sure your camera is on a firm tripod to avoid camera movement.

You may use direct flash (not umbrellas): this will allow you to use slower speeds and eliminate movement. A smaller stop can be used thus giving a more acceptable depth of field. The harsh lighting effect given by most electronic flash units suits this particular experiment very well. Once you have your lighting as you want it and the exposure checked, switch the background light on again and run off a complete roll of film.

In the Darkroom

Process the Tri-X for 10 minutes in Microdol-X at 68°F/20°C, or with Plus-X for 7 minutes. Fix, wash for 10 minutes and then hang to dry naturally in a dust-free area.

Make a set of black and white contacts and select a suitable frame.

From your continuous tone negative you need to make four line images on lith film. Three will be positives – one with an upright screen, one with a landscape screen, the third a straightforward unscreened positive. The fourth is a negative which is a direct reversal of the unscreened positive (fig. 4).

The next step has to be carefully considered; two elements are now very important to the final print:-
(1) . . . The size of the positive made from the original negative and
(2) . . . The size of the screen in relation to that positive.
First locate your screen. The simplest type of screen to use is that of the Letraset company; they make a variety of screen designs in complete sheets which can be bought at most good art supplies shops.

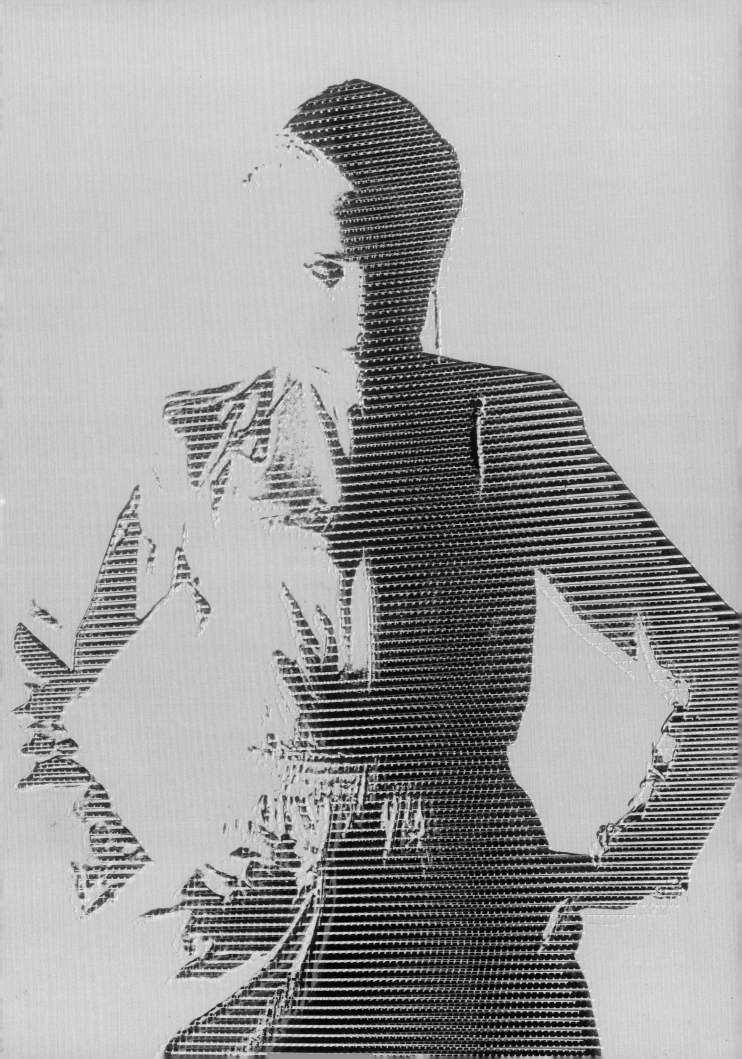

You must make your positive (from the original negative) as large as possible. 35mm is much too small, so the minimum size to work is $2\frac{1}{4}$" sq.; if you have a $\frac{1}{2}$ plate or 5" x 4" enlarger it will make the production and the matching of the line positives and negatives simpler.

The original negative, whether 35mm or $2\frac{1}{4}$" sq., needs to be enlarged so that the image is at least $1\frac{1}{4}$" overall when making your first line positive. The need for a larger size will become apparent when contacting the screened positives.

The Letraset is now carefully rubbed down onto a sheet of clear film the size that your are working, making sure that it does not bubble.

Change the safelight to red and project your chosen original negative onto the masking frame to the size already decided upon depending whether you are working at $2\frac{1}{4}$" sq. or larger.

Cut a sheet of 5" x 4" Kodak Reproduction film 4566 in half and make a test strip exposure. Pour out a small dish of Kodalith Super Liquid developer, 1 part A to 1 part B to 3 parts water at a temperature of 68°F/20°C. Develop the test for $2\frac{3}{4}$ minutes; fix, rinse, then dry. Assess the correct exposure from the test and expose the complete line conversion positive. Develop for $2\frac{3}{4}$ minutes at 68°F, fix, wash and then dry. Take this master positive (fig. 4A) to the light-box and with a fine sable brush and opaque block out any dust spots.

Next, make the line conversion negative (fig. 4B) by contact from the master positive (fig. 5). If this exposure is made by the light from the enlarger it should be roughly the same as for the positive.

Develop for $2\frac{3}{4}$ minutes at 68°F/20°C in Kodalith Super Liquid, fix, wash and dry. Carefully block out all dust spots with liquid opaque.

From this master negative make two screened positives by contact; at this stage it is important that these contacts are precise so make sure that the sheet of glass you use is heavy enough to squeeze the three sheets of film together (figs. 6 and 7).

Make one contact with the screen landscape and one with it upright. Develop, fix, wash and dry as before and you will have two screened positives. Carefully block out any dust spots with opaque.

The four sheets of processed film, three positives and one

negative, should look as in fig. 4.

The variety of ways in which these films may be combined in printing is endless; I will just describe how the illustration on page 84 was achieved.

I used two clean pieces of flat glass as a carrier. The unscreened positive was placed in the enlarger and projected up to within a 10" x 8" area; then a piece of A4 paper was taped to the masking frame (right up to the stops) and the projected image was carefully traced with a sharp pencil (fig. 8).

I stopped down to ƒ8, prepared the colour chemicals, making sure that the temperatures were correct. A pair of scissors were placed in a convenient place so they could easily be found in the dark. The filtration in the enlarger was set at 80C 80Y (to achieve a medium green) and a test-strip was exposed and processed in a rotary drum. I viewed the test (when dry) in a good even light. When assessing exposures from colour tests, on reversal paper, remember that to lighten colours you must increase the exposure time; to darken the image and improve colour saturation, cut the exposure. All the exposures for the next three stages were roughly the same.

I washed out the drum and throughly dried it. The white light was turned out and a 10" x 8" sheet of Ektachrome 14 paper was placed in the frame (the paper packet closed) and the exposure made.

Before it was placed in the drum the top right hand corner of the paper was cut off to mark it for later printing; the lid of the drum was then closed and the white light turned on. The negative carrier was taken to the light-box, the positive replaced by the screened positive (landscape) and taped along one edge onto the bottom glass: the line negative (unscreened) was taped exactly on top and the top cover glass was replaced.

I returned to the enlarger, switched on and registered the projected image exactly with the tracing on the baseboard.

The filtration was altered to 160M.

With the white light out the paper was taken from the drum and, making sure that the cut corner was in the top right-hand corner, it was replaced in the masking frame and exposed for a second time (18 seconds at ƒ8). The paper was returned to the drum, the lid closed, and the white light turned on. The carrier was returned to the light-box and the top cover glass again removed. I took off the top negative and registered the

A 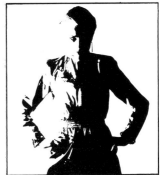 fig. 4

Line positive

B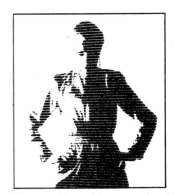

Line negative

C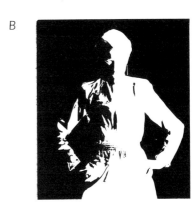

Line positive with screen landscape

D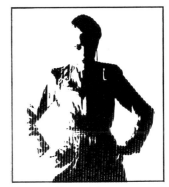

Line positive with screen upright

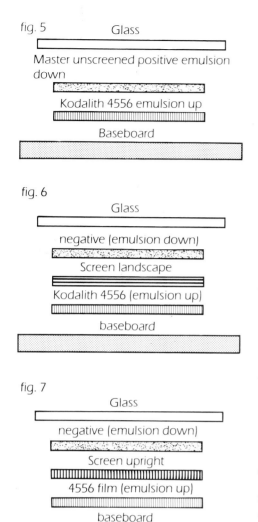

fig. 5

Glass

Master unscreened positive emulsion down

Kodalith 4556 emulsion up

Baseboard

fig. 6

Glass

negative (emulsion down)

Screen landscape

Kodalith 4556 (emulsion up)

baseboard

fig. 7

Glass

negative (emulsion down)

Screen upright

4556 film (emulsion up)

baseboard

second screened positive (upright) exactly to the screened positive (landscape), but before I taped it down I twisted it slightly to make an irregular pattern. The (unscreened) negative was retaped down exactly onto the positives and the top cover glass replaced.

The carrier was put back in the enlarger and the projected image was again fitted exactly to the tracing on the baseboard.

The filtration was altered to 160Y. With the white light out the paper was taken from the drum, the cut in the right-hand corner was checked and a third and final exposure made (18 seconds at ƒ8). The paper was returned to the drum, the lid closed and the white light switched on.

With fresh chemicals up to temperature the final multi-exposed print was processed as per the manufacturer's instructions. It was washed and dried and then inspected for colour balance.

Combinations of screens and filtrations just slightly altered can radically alter the look of the print. Not only is an infinite number of colour combinations possible, the variation of screens is also enormous. Curves, circles, dots and swirls can be used; they can be twisted and offset at all sorts of angles to each other and every movement produces a different effect.

Of all the experiments this is the most time-consuming, but the time is well spent for it is without doubt a fascinating exercise in colour and design over which you have almost total control.

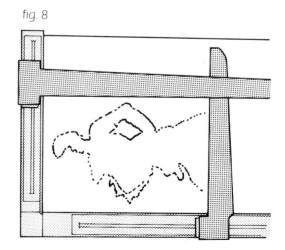

fig. 8

Trace down projected positive image with sharp pencil.

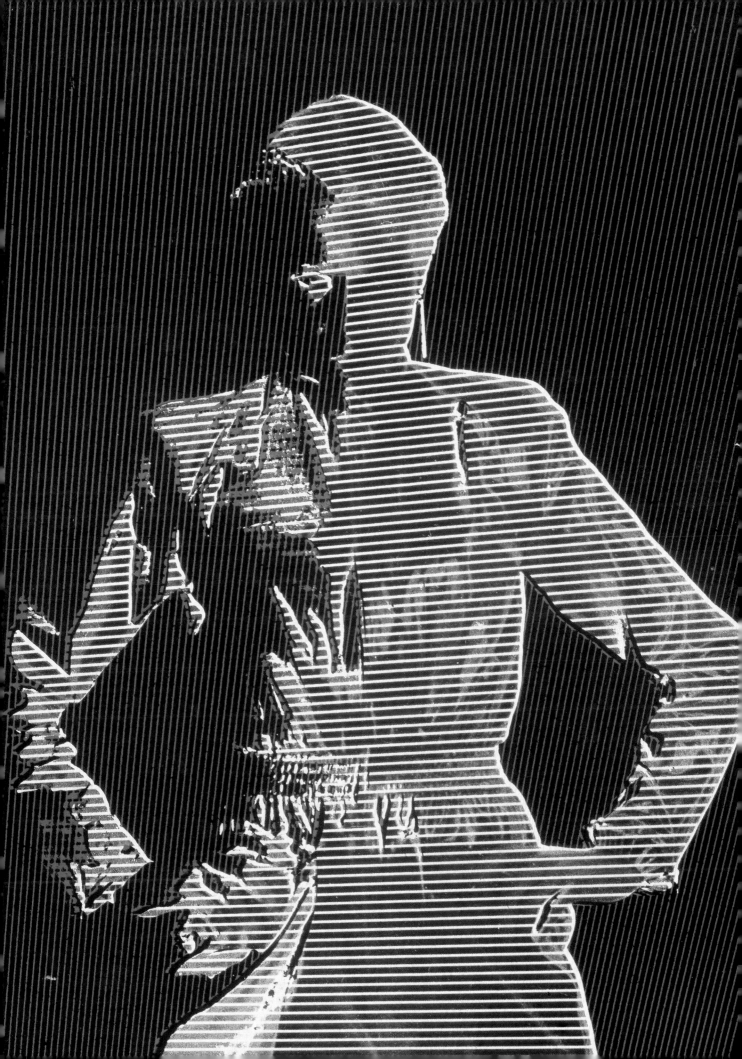

Hand Coloured Ghost Image

A strange modern effect; very up to date so it can only be used in limited areas. It is an ideal experiment to try with a pop group or modern dance and theatre set-up. A good strong final photograph will make an excellent poster. The surrealistic and ghost-like image with white shadows is achieved by making a solarized positive/negative but unlike the previous experiment on page 78 the positive/negative is not reversed back. The final black and white print is then hand coloured with photographic dyes.

This photograph, I believe, needs the human figure as a subject and carefully considered lighting on that figure for the whole concept to make sense. If a landscape is used it is very difficult (because it is in reverse) to make the shot 'read'. It really is a studio photograph.

In the Studio

You need two spotlights or two flash units with spotlight attachments that will cast long shadows. It might well mean you will have to hire a studio or use the local camera club's equipment and space. Many evening institutes or colleges of further education have studios with good all-round lighting equipment.

The background should be medium to dark grey and should extend to cover the whole figure (fig. 1). Make sure your figure is some 2 metres away from the backdrop or wall to allow room for the two spots to be far enough back to cover the whole of the figure with projected light.

The figure should be lit from the back with the spots – one from each side – keeping the light sources high and pointed downwards, this will avoid flare in the lens (fig. 2). If the shape you create with your model is radically different from the one illustrated, you may well need to use only one spot for lighting. As long as you have a good strong shadow on the floor

fig. 1

Backdrop must cover the whole of the
figure and allow enough extra to cover
shadow at the front

fig. 2

Spots high and pointed down to create
long shadows

and the complete image, i.e. the figure plus the shadow,
looks correct you will get the desired result. Use all of the
shadows as part of the composition, they are an integral and
important part of the whole photograph. They may become
almost as long as the figure, and longer, in some cir-
cumstances. The temptation is to cut off the shadow simply
because the figure plus the shadow gives a long thin image.
Resist this temptation; leave it all on. You can always cut off
any excess shadow in the final printing later on if you feel it is
necessary.

If you are using one spot, you may well need a fill-in just to
give the figure a little extra modelling. A large white card used
as a reflector may well do the trick; if this is not enough you
will have to use a small flood. However, do not get this fill-in
flood too close; it will only cancel out the shadow cast by the
spot.

Once the lighting is correct load the camera (2¼" sq. 6 x 6cm or 35mm) with Kodak Panatomic-X film, 32 ISO/ASA or Plus-X Film 64 ISO/ASA. Because of the lack of tonal values, due to lighting the figure with spotlights only, it is advisable to use a film with a lower ASA rating. This will, in fact, help to retain what little half-tone values there are.

Mount the camera on an adequate tripod to avoid any possible movement as you will need to get the aperture down to at least ƒ8. The shadow and the figure must be sharp so you need to cover a considerable distance to make sure that both the furthest point of the figure and the nearest point of the shadow are in focus from front to back. If with the aperture at ƒ8 the shutter speed becomes as slow as 1/15 of a second or more you will obviously have to remind your sitter not to move during the exposure time.

Be careful with the exposure. When using spotlights from this direction, exposure meters tend to under expose: i.e. if the meter reading is strictly adhered to, the resulting negative is thin.

Take a general reading of the whole subject and then a reading of the shadow detail. Compromise and use the middle exposure of the two read-outs. If your camera has a through-the-lens meter bracket the exposure, e.g. if the meter reads out at 1/30 of a second at ƒ8, make a second exposure at 1/15 of a second at ƒ8.

Run off a complete roll of film, changing the lighting and the model's pose quite radically from frame to frame to give yourself plenty of choice.

In the Darkroom

Develop the Panatomic-X in Kodak Microdol-X (undiluted) for 7 minutes at 68°F/20°C. Agitate for at least 15 seconds every minute – this will help to retain the subtleties in the shadow detail. Fix, wash for 10 minutes and then hang the negatives to dry naturally in a dust-free area. When the negatives are thoroughly dry make a set of black and white contacts and select a suitable frame.

If you are using a 35mm camera the next step is to enlarge the negative to 2" on the baseboard as in fig. 3. If you are using 2¼" sq. (6 x 6cm) make the next step as a contact.

Pour out a small dish of Kodalith Super Liquid developer, 1 part A to 1 part B to 3 parts of water at a temperature of 68°F/20°C. Change the safelight to red. Cut a sheet of 5" x 4"

fig. 3

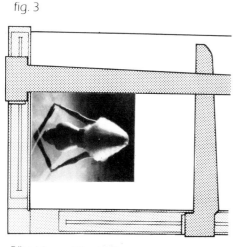

2" wide on 5" x 4" film

88

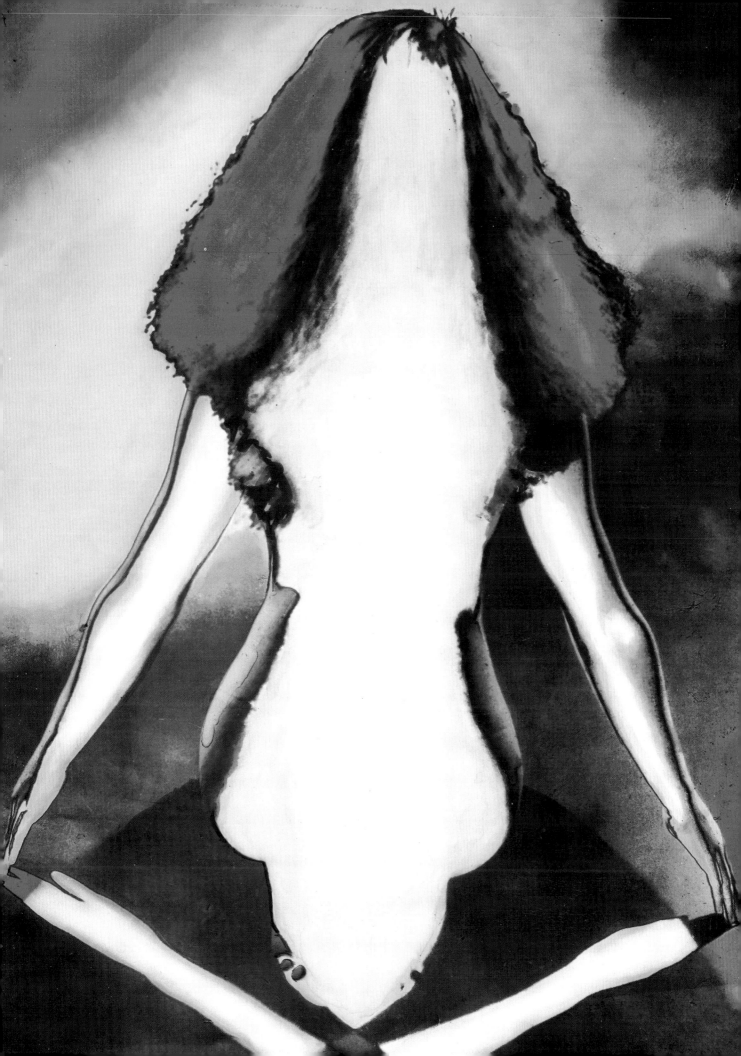

fig. 4

Safelight

Develop for 1 minute (approx) Switch white light on for 3 seconds or Turn film over – emulsion side down
bounce flash off ceiling

Kodalith Ortho film 4556 in half and expose a test-strip. Develop for 2 minutes. Fix, rinse and dry. You should have a bright hard positive. Choose the appropriate exposure assessed from the test-strip and then expose a full sheet of 5" x 4" 4556 film. The processing is the same as for the Solarized Image on page 58, as follows:

Place the film in a dish of developer emulsion side up and rock the dish gently. After about a minute the image will begin to appear. As soon as the shadows (black areas, this being positive) begin to thicken-up, switch on the white light for about 3 seconds; the exact time depends on the power of the light source and its distance from the dish and will only be established by trial and error. Alternatively use a flash bounced off the ceiling (fig. 4).

Turn the film over so that it is emulsion side down. The highlight or white areas will now begin to fill in and fog over. The secret is to get the film into the fix before the fogging in the highlight detail completely blanks out the film. You will probably need one or two attempts to get this stage correct. Time the three stages very carefully in your own conditions: first, the initial development, then the white light exposure time, and finally the development time after the white light has been switched on and off. Fix this film which is now a positive/ negative for 3 minutes. It is always important when transferring a developed film from developer to fix to agitate it thoroughly. In this particular case make absolutely certain that fixing is quick and thorough, it will prevent air bubbles forming and developing marks occurring. Wash for 5 minutes and then dry.

Develop with the emulsion side down then fix
until the highlights begin to fog over

There is no need to reverse this positive/negative back (as in the solarized version on page 58); use it as it is. First, however, take it to the light-box and spot out any dust spots with retouching dye and a fine sable brush.

Make a first class 10" x 8" black and white print. Make sure that the whites are clean and the blacks are strong and dense. If necessary print on grade 3 paper, this will help you keep the print clean and bright. Fix the print and then wash thoroughly for 20 minutes. Make sure the emulsion is completely free of chemicals, then dry the print.

The final task of hand colouring the print I can only leave to your discretion. The illustration is a guide and a personal interpretation for that particular photograph. The only secret is to build up the colour; start with a thinly diluted amount of dye and then increase the strength of the colour by stages. Do not use the dye neat and direct unless you want a particularly garish result. Use your artistic talents; you will derive a great deal of satisfaction in using colours imaginatively. Mount the final print on card.

Multiple Images

This experiment makes use of the posterisation method (example on page 120) but adds a further complication by using solarized components for printing. This presents something of a challenge but with careful and methodical working – as can be seen from the illustrations – a wide range of striking pictures can result from just one original.

In outline, the experiment is to print a suitable black and white negative on to lith film: whilst processing this line positive it is solarized. The solarized positive is then used to produce a set of negatives for posterisation, and in turn are reversed to positives to print a positive solarized photograph on to Ektachrome 14 paper using filtration to give colour.

Almost any subject can be chosen to photograph for this particular process. If you do select a portrait as illustrated, make sure the lighting is strong and bold. My own illustration was a studio shot but it may well be worth trying a location shot on a bright sunny day.

On Location

Seat your model against the sun in the early morning or late afternoon with the sun behind the head creating a halo effect as in fig. 1. The face, obviously in shadow, now needs a fill-in. Sometimes, if it is very early, just after dawn, the sun will be weak enough for just a white card to fill in the shadow detail. In most cases however, a flashgun has to be used to fill in the shadows as in fig. 2.

Hold the flashgun away from the camera, attached to an extension lead. Keep it high and to one side; this will help give some modelling and depth to the face.

Load the camera with Tri-X or Plus-X film. The calculation of the exposure can in some cases be quite tricky. If you expose the film using the figures given on your flashgun, you will almost certainly find that a combination of natural light and

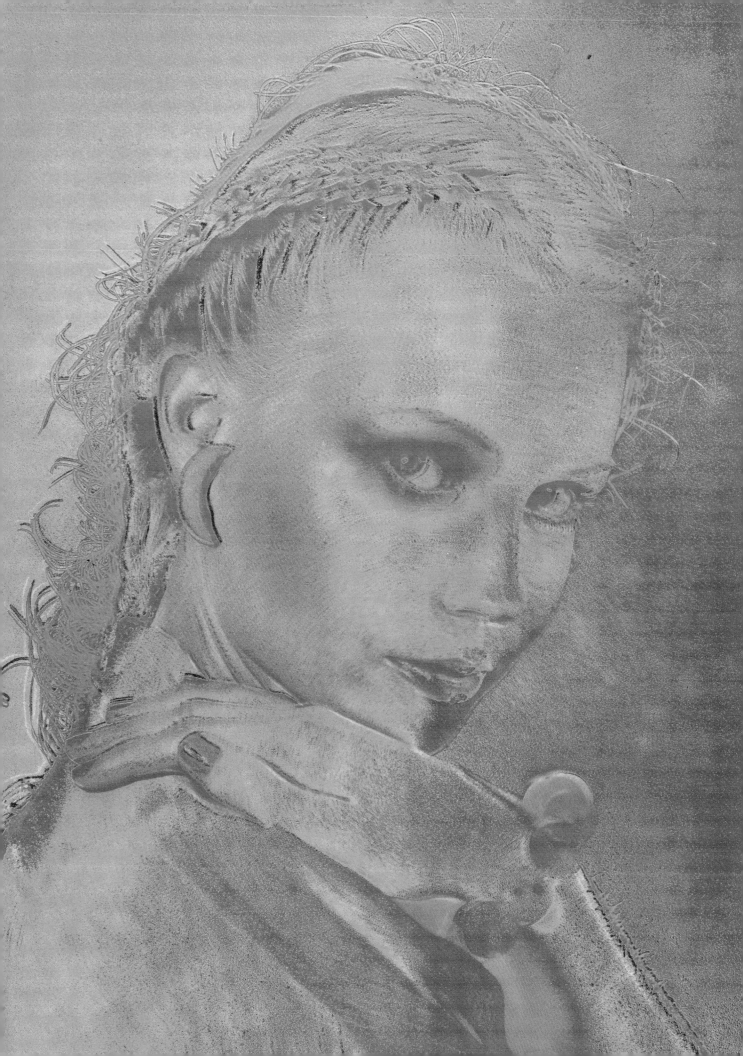

flash will result in an over-exposed negative. The answer therefore is to bracket the exposure, e.g. if the calculation from the flash gun reads out at 1/60 at *f*16 make three more exposures:

1) 1/60 at *f*16+
2) 1/60 at *f*22
3) 1/60 at *f*11+

The second exposure, although it may well give you a thin negative, will help enhance the halo effect around the head. It may well be worth exposing a few frames if your flashgun can be switched to half power; in this case keep the exposure settings on the camera at the readings given for the full power calulations on the flash.

If the location you have chosen has groups of trees in the vicinity, use them. Bright sunlight filtering through the leaves will give the photograph a strong background with a wide range of tones, right through from bright highlights to dense blacks in the shadow details. Keep the mood of the photograph free and informal. A simple straightforward approach using the background and the sitter complementing each other is much better than an involved, fussy and formal portrait with elaborate gimmicky props. The word natural springs to mind; keep everything in context.

For an outdoor portrait the sitter requires less make-up than usual and the dress should be informal. The hair style can be loose and free and if there is a breeze about use it to your advantage. Let it blow through the hair – it will give life and movement to your photograph. Run off a dozen or so shots to give yourself plenty of choice.

In the Darkroom

Develop the Tri-X for 10 minutes in Microdol-X (undiluted) at 68°F/20°C or, if using Plus-X, 7 minutes. Fix, wash for 10 minutes and then dry naturally in a dust-free area. Make a set of contacts and select a suitable frame.

Change the safelight to red and pour out a small dish of Kodalith Super Liquid developer, 1 part A, 1 part B, to 3 parts water at a temperature of 68°F/20°C. Take the selected negative and, if a 35mm, place it in the carrier and enlarge to 2" wide; if 2¼"sq. (6 x 6cm) make a contact (emulsion to emulsion).

Expose a test-strip on half a sheet of 5" x 4" Kodalith 4556 film. The development time is 2¾ minutes and after fixing, rinsing

fig. 1
Photograph into early morning or late afternoon sun, the face in shadow

fig. 2
Fill-in with flash on a long synch lead

and drying the test image will show as a bright hard positive.

Choose a suitable exposure from the test and expose a complete sheet of 5" x 4" Kodalith 4556 film at this exposure.

Place the film in the dish of developer emulsion side up and rock the dish gently. After about a minute the image will begin to appear. As soon as the shadows (the black areas, this being a positive) begin to thicken-up switch on the white light for about 3 seconds. (The time depends on the power of the light source and its distance from the dish and it will only be established by trial and error). Alternatively use a flash bounced off the ceiling (fig.3).

Turn the film over so that it is emulsion side down. The highlight areas i.e. the white areas will now begin to fill in or fog over. The secret is to get the film into the fix before the fogging in the highlight detail completely blanks out the film. You will probably need one or two attemps to get this stage correct. Time the stages very carefully in your own conditions first the initial development, then the white light exposure time, and finally the development time after the white light has been switched on and off. Fix this film which is now positive/negative for 3 minutes. It is always important when transferring a developed film from the developer to the fix to agitate it thoroughly. In this particular case make absolutely certain that fixing is quick and thorough, it will prevent air bubbles forming and developing marks occurring. Wash for 5 minutes and then dry.

When the solarized pos/neg is dry, cut a sheet of Kodalith 4556 film in half and contact a test-strip (fig. 4). Solarized pos/negs tend to be much denser than normal negatives, so increase the exposure of the test accordingly. Develop the test for 2 minutes in Kodak DPC print developer diluted 1 to 9, (not the Super Liquid), at a temperature of 68°F/20°C. Fix, rinse and then dry.

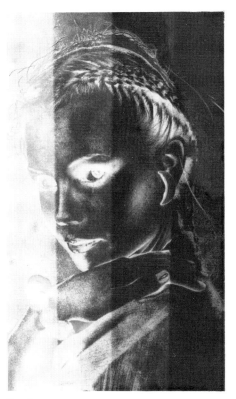

fig. 4
Test strip 2 4 6 8

fig. 3
Bounce flash off the ceiling

Assess the exposure from the test and make a contact exposure on to a complete sheet of 5" x 4" 4556 film; develop for 2 minutes as the test, fix, wash for 5 minutes and dry. From this neg/pos expose a contact reversal on to Kodalith 4556 5" x 4" film and process in Kodalith Super Liquid developer for 2¾ minutes at 68°F/20°C Fix, wash for 5 minutes and then dry.

You now have three films as in fig. 5(i) (ii) and (iii). 5(i) is a solarized pos/neg from the original negative with a good range of half tones. 5(ii) is a neg/pos but because it is developed in a print developer it still retains a proportion of half tones. 5(iii) is a line pos/neg with good clear highlights: although it is quite dense it will allow a printing colour filter to be projected on to Ektachrome 14 paper.

fig. 5

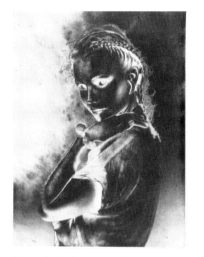
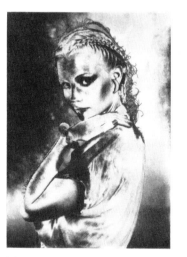
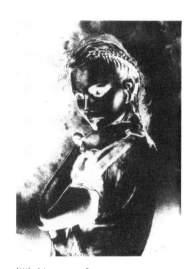

(i) original solarized pos/neg

(ii) Neg/pos from original pos/neg

(iii) Line pos from neg

The Enlargement

These three films are printed in sequence as in the posterisation process in experiment 100. Obviously the subject photographed will have a direct bearing on the first solarized pos/neg 5(i) but usually this can be regarded as the normal (middle stage) film; the thin one is the reverse neg/pos 5(ii) and the heavy one is the line pos/neg 5(iii). A general rule is to print the thin one first, the normal one second and the heavy one third. Follow this method, which was used to achieve the illustration on page 101.

I suggest that you first make up a carrier with two pieces of glass (5" x 4"). Thoroughly clean one piece of glass and lay it on the light-box: On it place the thin neg/pos 5(ii) and tape it down one edge. Take the normal pos/neg 5(i), place it on top and manoeuvre it until the images exactly. Tape the front

fig. 6

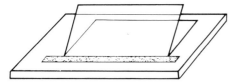

Sellotape edge of 5 (i) to 5 (ii) to make a
hinge

fig. 7

Sellotape 5 (iii) to 5 (i) and 5 (ii) to make
second hinge

fig. 8

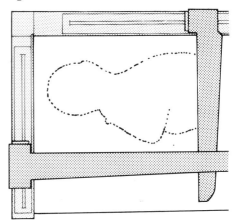

Trace down projected image

edge with Sellotape and make a hinge (fig. 6). Place the third
line pos/neg 5(iii), the heavy one, on top, again registering it
exactly. Once more tape down the front edge making a sec-
ond flap (fig. 7).

Flap the top positive to one side and place the second glass
on top. Return the made-up carrier to the enlarger and size up
the projected image on 10" x 8". Tape a sheet of A4 paper up
to the stops of the masking frame and carefully trace with a
sharp pencil the outline of your subject (fig. 8). You may find
that you have light spill from this carrier so you must be pre-
pared to block it off when printing.

Return to the light-box, flap the medium positive back thus
leaving the thin positive in place: replace the cover glass, re-
turn the carrier to the enlarger and register the projected
image with the tracing again.

Make sure you have ready a packet of 10" x 8" Ektachrome 14
paper, a rotary drum, colour chemicals in their separate con-
tainers and up to temperature, and a pair of scissors.
Memorise the position of the scissors.

A test-strip is, I find, of little value in this particular process, it is
advisable to go ahead and attempt a complete print.

Because of the varying densities of the original solarized pos/
negs it is not possible to give a general guide for exposures
that will be anywhere near accurate. You will have to be
guided by your own darkroom experience, or test very care-
fully in your own conditions. I will give the exposures and the
filtration I used in my own experiment, but it can only be used
as a guide.

Your first neg/pos 5(ii) is in position. Dial in 160Y (or any colour you choose, simply bear in mind that all the colours should be complementary), stop down to $f8$, turn out the white light, take a sheet Ektachrome 14 paper from its packet; expose for 4 seconds, and before you place the paper in the drum cut off the top righthand corner with scissors (this will be a guide for later printing), close the lid and switch on the white light. Return the carrier to the light-box, take off the top cover glass and flap the middle pos/neg 5(i) on to the thin one and replace the glass.

Return the carrier to the enlarger and register the projected image exactly with the tracing again. Use 160M filtration and turn out the white light. Take the paper from the drum and place it in the masking frame, making sure that the cut is still in the top right-hand corner with scissors (this will be a guide for later printing), close the lid and switch on the white light. Re-drum closing the lid.

Return to the light-box with the carrier and remove the top cover glass and flap the third line pos/neg 5(iii) on to the two others, then replace the top cover glass.

Return the carrier to the enlarger, switch on and check that the projected image fits the tracing exactly. Dial in 80C. (This next exposure creates the highlights: with three combined exposures on the paper, the areas affected by the final exposure will go white if your exposures are sufficient; however, it is worth adding colour filtration because occasionally this third colour picks up in certain shadow areas thus giving a further dimension to the print.

Turn out the white light; take the paper from the drum and place in the masking frame, again check that the cut is in the top right-hand corner and make sure that you do not move the frame. Expose for 12 seconds, return the paper to the drum, close the lid and turn on the white light.

Double check that the colour chemicals are up to temperature and process as per the maufacturer's instructions. Wash and dry the final print.

Further effects can be achieved just by printing either the first (original) solarized pos/neg and its reversal together with a single colour; or two other films leaving out the original solarization. In both cases vary the colour schemes. If you really want to be ambitious, reverse 5 (i) (ii) and (iii) on to line film; this will give you six different films to experiment with. Try printing four of them off-set and in sequence using pale muted colours, or, use all the neg/positives combined with bright garish colours. The combinations of films and colours seems to be infinite; it really is an experiment to stretch the imagination to its limits.

Sepia Posterisation

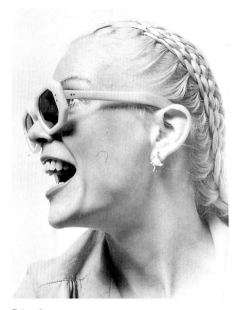

Print from original
negative

This is a posterised print on black and white bromide paper taken one stage further than usual simply by changing the middle tone to sepia (brown). One could tone the whole print sepia but the strongest tone – the black – tends to show little change to brown.

With this particular method there is a definite change in the tonal values: a good strong black in the shadows, warm brown mid-tones and clean white highlights.

The location/studio photography and the processing of the original negatives are carried out as in the colour posterisation, experiment No. 17, up to and including the set of black and white contacts from your chosen subject. The darkroom work, however, is different.

You will need three line negatives (not positives as in the colour version) to be printed in sequence onto a sheet of bromide paper. These three negatives need to be as large as possible as this will make for easier and more precise working in the darkroom later on. The three positives for the colour version were arrived at by darkroom work: there is however a second method by which we can arrive at the negatives required for the black and white print, as follows:

Select the best frame from your contact sheet and make a first-class 10" x 8" print with a ½ inch border (actual picture area 9" x 7"). If you are not using the new resin-coated papers make sure the print is flat when it is dried; dry-mount it onto a piece of card if necessary.

Carefully spot the print and add four black crosses, one to each corner, in the white border as in fig.1.

You now need three copy line negatives of this print.
This creates a problem: the ideal format is 2¼"sq. (6 x 6cm) or larger; unfortunately, neither Kodalith 4556 film nor any other line conversion film is made in 2¼"sq. size. 35mm is too

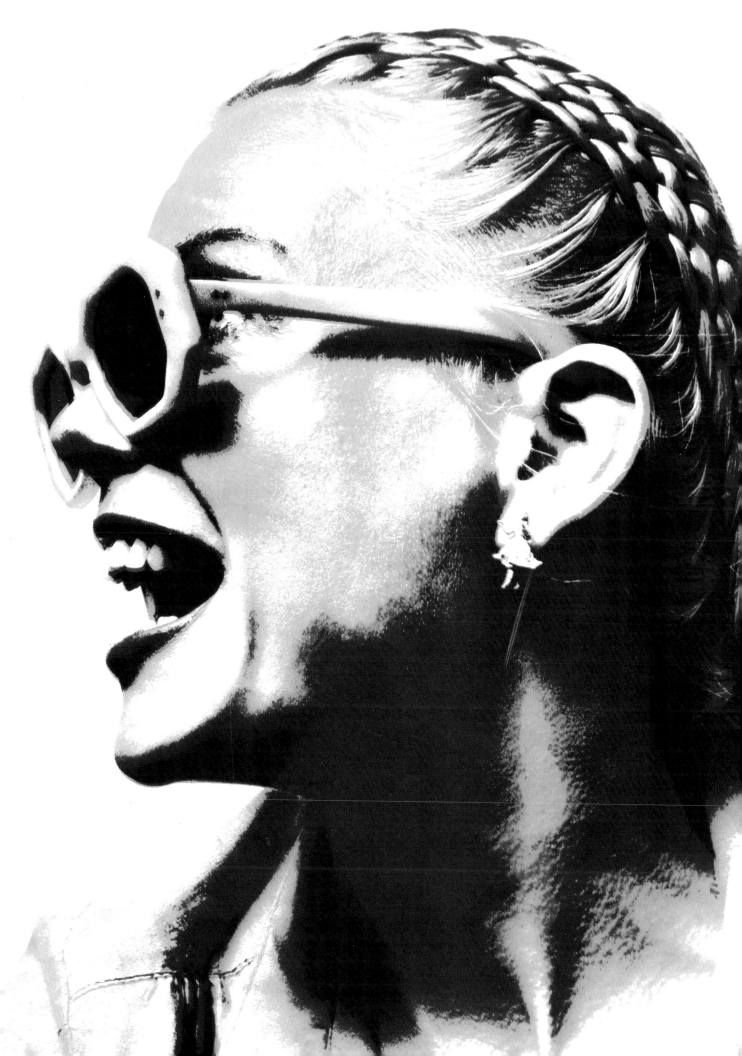

fig. 1
First class 10" x 8" B/W bromide print
4 crosses, one in each corner

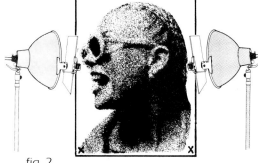

fig. 2
Even lighting with floods

small, so you will have to use a larger size plate camera, either 5" x 4" or 1/2-plate (61/2" x 43/4").

Many camera clubs and most evening institutes with photographic courses use large format cameras; if you are friendly with a professional photographer he may be good enough to let you use his equipment. It's worth asking – you will be surprised how most professionals are only too willing to help the keen enthusiast. Obviously with large format negatives you will also have to acquire the use of a large format enlarger to do the print.

In the Copying Room

Pin the print to the board making sure it is upright and light it evenly with two floods, one from each side as in fig. 2.

Mount the camera (5" x 4" or 1/2-plate) on a firm tripod, and fill the ground-glass screen with the print but make sure that all the four crosses are within the area. Get the camera square to the print on the board making sure that the back and the front panels are square in both the horizontal and vertical planes (fig. 3). If you are not familiar with large format cameras make sure you are supervised. If the negatives are not square, poor definition could result, especially on the extreme edges where the crosses are. This will make printing more difficult later on.

Once satisfied that the camera is square and the lighting correct and even, load a slide with Kodalith 4556 film.

The exposure is the same as for the positive in the colour posterising experiment – namely :- 1: 3: 5 and you will need to make a test.

Place the slide in the back of the camera. Stop down to say f11, set the shutter speed to 1 second and cock it. Pull the sheath out fully (fig. 4) and press the release. Put the setti

fig. 3

Front and back square

Camera and board square

5" x 4" or 1/2 plate camera

B and reload the shutter; push the sheath down to just before half way (fig. 5) and make a second exposure of 2 seconds. Reload the shutter and push the sheath down to ¾ of the way (fig. 6) and make a third exposure of 2 seconds. Then push the sheath home: you now have a series of test exposures at 1, 3 and 5 seconds.

In the Darkroom

Pour out a small dish of Kodak Super Liquid developer 1 part A to 1 part B or 3 parts water at a temperature of 68°F/20°C and under a red safelight develop the test for 2¾ minutes; fix, rinse and dry.

We are trying to get three negatives...
1) a thin negative for the highlights/shadows
2) a medium negative for the mid-tones, and
3) a dense negative for the shadows/highlights.

Obviously the figures I gave for the test can only be a guide; you will have to test in your own conditions but as long as the ratio of 1: 3: 5, e.g. 2: 6: 10, 3: 9: 15 and so on is adhered to, you will achieve your objective.

Check the test negative carefully (fig 7). The middle exposure has got to be 'normal': that is, a strong black for the highlights, clear and bright areas for the shadows and steeply graduated mid-tones. Although made on line film it should look like a good strong continuous tone negative; unlike the thin one that will have a few dark areas surrounded by clear film, and the dense one that will be mostly solid black with a minmum of clear areas. Make more than one test, if necessary, to achieve this. When satisfied, expose three sheets of film for the selected times and process them together, as for the test. Fix, wash for 5 minutes and hang to dry naturally on a line, each one clipped from one corner only; this will prevent uneven stretching. It is preferable, though not essential with modern film base, to hang each one from the same corner.

fig. 4
Pull sheath out fully and expose for 1 second

fig. 5
Push sheath down ½ way and expose for 2 seconds

fig. 6
Push sheath down to ¾ and expose 2 more seconds

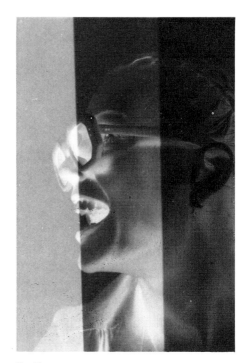

fig. 7
Test strip 1, 3 and 5 seconds

The Enlargement

Most 5" x 4" and ½-plate enlargers have glass in their carriers so there is no need to make one up.

Take the three negatives to the light-box and spot out any dust spots with opaque and a fine sable brush. They should look as in figs. 8a, b and c.

The negatives have to be printed on to bromide paper but also combined with each other in the three successive stages: in other words, the first printing exposure is made through the thinnest negative alone, the second through that negative plus the medium negative combined and the third is made through all three together (fig. 9)

Tape the medium negative (8b) to the bottom glass of the carrier, place it in the enlarger and size it up to 10" x 8". Place a sheet of A4 paper in the masking frame and with a sharp pencil trace the projected image, including the 4 crosses.

fig.8

A 1 sec. Thin neg

B 3 secs. Normal

fig. 9

Print neg C combined with neg A & B third

Print neg B combined with neg A second

Print neg A the thinnest one first

C 5 secs. Dense

Return to the light-box and replace the medium negative (8b) with the thin one (8a). Place the medium negative (8b) on top and manoeuvre it until it is exactly in position, using the four crosses as a guide. Tape the front edge with Sellotape and make a hinge (fig. 10) Place the third negative, the heavy one (8c), on top, manoeuvre it around until it fits exactly. Tape down the front edge again making a second flap (fig. 11).

fig. 10
Tape front edge with tape and make a hinge

fig. 11
Place heavy neg (fig 8 C) on thin and medium negs to make a second hinge

The Print

The exposure timing sequence for the print on paper is 2:4:6.

Flap the medium and heavy negatives back outside the carrier and return it to the enlarger: match the projected image exactly to the tracing again, using the four crosses as a guide. Stop down to f8. With the yellow safelight on, take a sheet of paper from the box, close the box, and expose the first image for 2 seconds (a test-strip for this print is of little help, it is better to go ahead and do a complete print). Before you return the paper to its box, cut off the top right-hand corner with scissors (this is a guide for later printing). Close the lid of the paper box. Flap the medium negative on to the thin one, checking that the crosses match and return the carrier to the enlarger. Match the projected image exactly to the trace again. In the yellow light take the paper from the box, make sure that cut corner is still in the top right-hand and place it in the frame right up to the stops (being careful not to move it) and make a second exposure of 4 seconds. Replace the paper in the box, close the lid and return to the light-box again. Flap the final negative, the heavy one, on to the thin and medium negatives (checking that they fit) and return the carrier once again to the enlarger. Switch on and check that the projected image matches the tracing exactly. (This heavy negative is the most difficult one to match so use four crosses as a guide). In the yellow light take

the paper from its box, check that the cut corner is still in the top right-hand and place it in the frame without moving it; make a final exposure of 6 seconds.

Pour out a dish of Kodak DPC developer diluted 1 to 9 at a temperature of 68°F/20°C. and develop for 1 1/2 to 2 minutes. Fix, rinse and dry.

Take the print into a good light and check that the middle greys do not merge with the blacks: if so, reduce the overall exposures. Likewise, if the mid-greys are too light, increase the exposures, but remember, if you either increase or de-crease the exposures they must still be in the ratio of 2: 4: 6.

Once you have a satisfactory print, i.e. with good strong blacks, an even medium grey and clean whites, thoroughly wash the print for 20 minutes. All the hypo and other chemi-cals must be removed from the emulsion if a successful sepia-toned print is to be achieved.

You can now sepia tone the complete print or follow the method which I prefer:-

Pour out a small dish of bleach (one part potassium bromide to four parts potassium ferricyanide) at a temperature of 68°F. Alongside it have a dish of sodium sulphide solution, also at 68°F. Have handy a beaker of clean water and a sheet of blot-ting paper.

Place the print on a clean, dry surface and with a fine sable brush carefully bleach away the grey middle tones only (fig. 12). Use the blotting paper to prevent the bleach from spread-ing into the black areas. When all the grey areas have been bleached, rinse the print until the yellow colour disappears. Re-develop the print in the sulphide solution; wash for 10 mi-nutes and dry.

To get the balance of this print correct requires patience more than skill. Once the balance is achieved and you have a print looking right you will find it one of the most rewarding of these experiments. It is a process that has, quite rightly, sur-vived for many years.

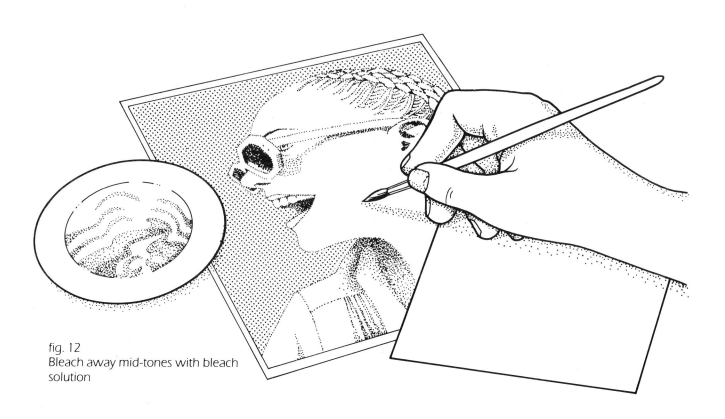

fig. 12
Bleach away mid-tones with bleach
solution

Zooming
by Enlarger

A comparatively recent addition to the photographer's gadget bag is the *zoom* lens. It has a distinct advantage – it is flexible and does away with the need for a battery of lenses to cover all occasions.

A technique that has evolved with the introduction of the zoom lens is the 'zoomed photograph'. In the area of sports photography, many fine and startling images have been created simply by setting the shutter at a slow speed (approx. ½ second) and then zooming the lens during the exposure.

Print from original

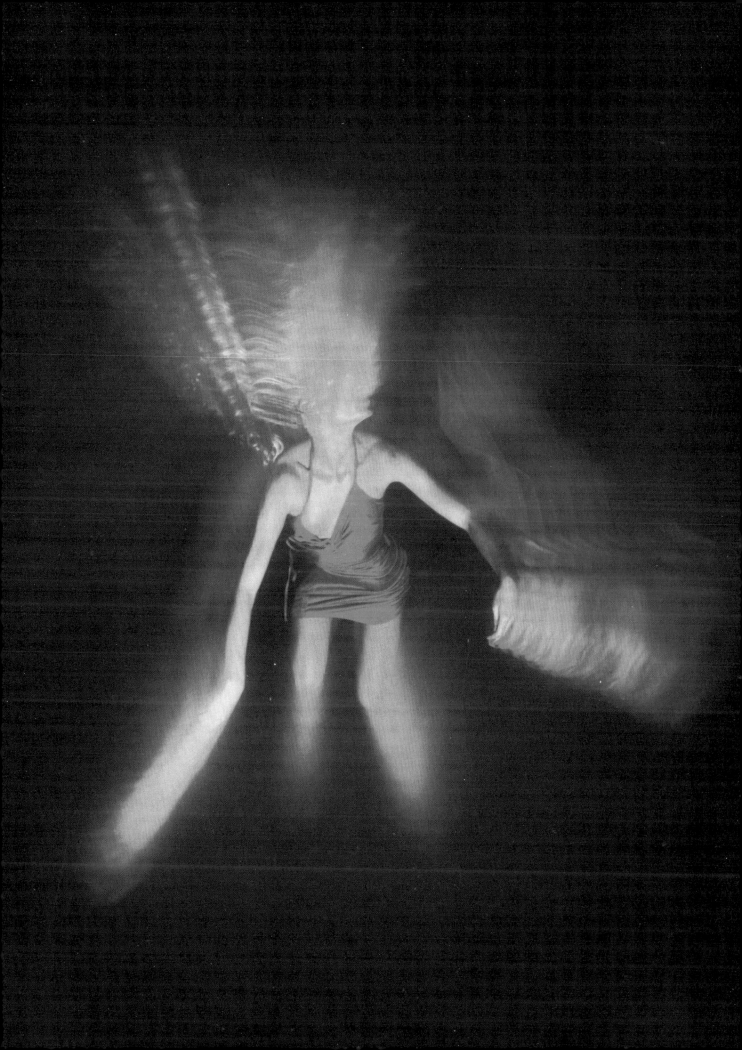

The illustration on page 109, however, was achieved without a zoom lens, simply by printing using a technique which, I believe, gives more flexibility. I chose a transparency from my file but it had in fact an important characteristic – the subject was light in tone against a black background.

To achieve any sort of reasonable result the background must be a single dark colour, or black if possible; for example a subject that could work quite well would be a seagull against a dark, deep blue sky. Check through your files and seek out a transparency that has a fair amount of action in the subject matter and a background that is plain and dark.

In the Darkroom

At first sight the darkroom procedure seems straightforward: the transparency is placed in the carrier of the enlarger and sized up to about 3½ inches deep within 10" x 8" print area. It is then exposed on a sheet of Ektachrome 14 paper and during the exposure the enlarger is moved up in stages until the projected image is to its full size within the 10" x 8" area, maintaining the focus as accurately as possible throughout. However, there is a snag: the exposure has to be gradually increased as the image becomes larger and because of the continuous exposure at the centre of the image, by the time the exposure for the whole is completed, this central area has become overexposed and meaningless (fig. 1). The problem is overcome thus:-

Size the transparency up to full size at 10" x 8" on the masking frame and then reduce the image down to about 3½ inches (fig. 2) and check that the image is at all times contained

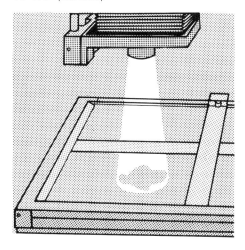

fig. 1
Photoprint of burned out centre portion

fig. 2
Size up image to 3" (minimum size) and
10" x 8" (full size)

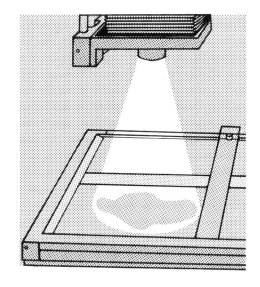

within the the masking area. I find it easier to work from the smaller image up to the larger, rather than the other way round, as I have more control. Stop down to ƒ8 and set the filtration recommended by the manufacturers in the packet of Ektachrome 14 paper. Pour out the colour chemicals and bring them up to temperature. Expose test-strips for both the initial size (3½") and the final one (10" x 8"). These will give you a definite guide throughout the exposure. Process and rinse the tests and when dry write on the back of each the exposure, filtration and overall size that the transparency is enlarged to (important when only part of the transparency is used).

Once the filtration and the exposures are determined make two masks out of black card: (1) an 8" x 6" sheet with an oval cut out of the middle about 4 inches long as in fig. 3, and (2) a dodger. This is a 2 inch oval-shaped piece of black card attached to a thin piece of wire as in fig. 4.

fig. 3
Cut 4" oval out 8" x 6" black card

fig. 4
Dodger – made of 2" black card oval and thin wire

You must make a dummy run of the next stage without sensitised paper and with just the safelight on to help you judge the steps.

Check that the masking frame has not moved and that the enlarger is stopped down. The main image is at about 3½". With the first mask (1) in position make the first exposure moving the mask with a sieve-like movement (fig. 5) to vignette the image. Once the initial exposure has been completed the opposite effect is required; most of the main image needs holding back so the dodger has to be supported in a way that leaves the hands free to move the enlarger upwards.

I suggest wiring it by a thin loop around the filter stalk, taut enough to hold it at each stage, but not so tight it cannot be easily moved between stages. You will then be able to move it gradually up towards the lens during the exposure (fig. 6)

fig. 5

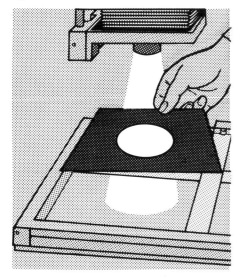

Vignette with sieve-like motion

Another practical way of dealing with this problem I found was to hold the dodger between my teeth, thus leaving my hands free to switch on and control the movement and the focus on the enlarger; this may sound odd but I can assure you that it works! The dodger masks out the centre of the image, leaving only the edges to create the moving effect. During the upward movement of the enlarger the image needs constant re-focusing to keep it as sharp as possible. And, of course, the exposure must be increased so that if, for example, your first exposure is 6 seconds, your last, when the image is to the full 10" x 8" size, will be about 30 seconds.

fig. 6

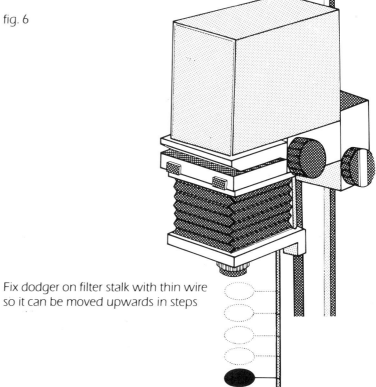

Fix dodger on filter stalk with thin wire so it can be moved upwards in steps

It might be worth-while very carefully working out each movement upwards stage by stage (getting the image sharp each time), and moving the dodger correspondingly upward in controlled single exposures. This, however, can give a stepped, regular and, I think, uninteresting effect. I prefer to keep the enlarger lamp on throughout the exposure so that the out of focus parts, caused inevitably by racking-up the enlarger, still register. (It is worth experimenting with both methods to find the result you prefer. You should also be able to work out your own practical method of dodging based on the examples described).

When you think you have a dummy run completed to your satisfaction, expose a complete sheet of Ektachrome 14 paper (based on your test-strips) and process it as per the manufacturer's instructions. The finished print will show you very clearly where any mistakes are. Of all the experiments this is the one that needs the most patience and is the most subject to trial and error. It can be time-consuming and frustrating but the reward for patience is a print with the stamp of originality only you can produce, unlike the photograph taken with the zoom lens that tends to look slightly mechanical. Mount the final print on card.

Fantasy in Colour

This is the sister technique to the Negative Colour in Outline on page 52. The strange ghost-like effect is achieved by using a black and white negative in conjunction with a black and white positive; both are printed onto reversal colour paper, each with its own colour filtration.

However, two shades of the same colour are used when filtering the positive and negative: this gives the final result a radically different look from the colour negative process that uses differing colours.

I found in my experiments that the human face provided the best subject for this particular technique. It really is pure fantasy photography and can be used to create a visual shock, but the variety of images created just by altering the exposure and colour filtration is quite startling.

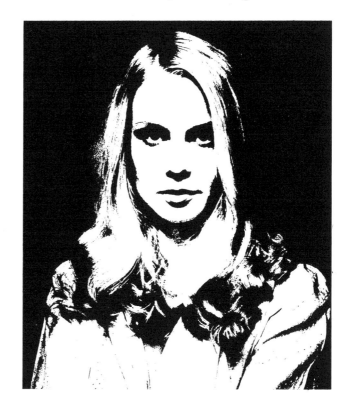

fig. 1

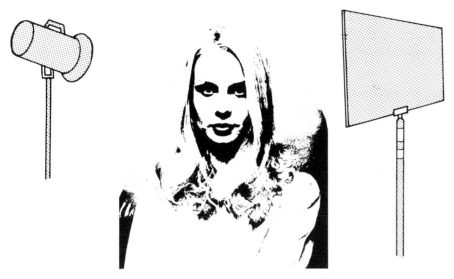

Strong sunlight from one side or flood/
spot and white card reflector

On Location or in the Studio

Find a model, male or female, with strong features and take various shots with the head fairly full in the viewfinder. Strong lighting is advisable, either sunlight from the side or, if in a studio situation, a spotlight or flood with a white card on the far side just to lighten the shadows (fig. 1). Use Tri-X or Plus-X film and run off a dozen or so shots to give yourself a wide choice. Be accurate with your exposures.

In the Darkroom

Develop the Tri-X film in Microdol-X (undiluted) at 68°F/20°C for 10 minutes; for Plus-X development time will be 7 minutes. Fix for 5 minutes, wash for 10 minutes and then dry the film naturally.

Print a sheet of black and white contacts and select a suitable frame.

This master continuous tone negative is then printed onto a line film to make a positive and from the positive a further negative is made, also on line film. But, instead of processing the film in lith developer to produce a hard line result, it is processed in a standard print developer to produce a bright hard positive or negative, but retaining some of the mid-tones.

Change the safelight to red and cut a sheet of 5" x 4" Kodalith 4556 film in half and contact a test strip from the chosen negative. If you are using 35mm it may become a bit fiddly to make a satisfactory test so print it complete three or four times onto the sheet of 5" x 4" film, at different exposures, you will then not only have done a test, but one of the exposures could be cut out and used. Develop in Kodak DPC print developer (dilute 1 to 9) for 1 ½ to 2 minutes at 68°F/20°C., with constant agitation. Fix, rinse and dry the test.

Check on the light-box and choose the most appropriate exposure. Contact (or print) a complete sheet of film and process as the test. When the positive (2A) is dry, again check it over the light-box and spot out any offending dust spots with a fine sable brush and black retouching dye.

Contact this positive (emulsion to emulsion) onto a further sheet of Kodalith 4556 film (the exposure should be roughly the same) to produce the semi-line negative. Process in the same developer (DPC) to retain some of the half-tones. Fix, wash for 2 minutes and dry. Check on the light-box and spot out any dust. The semi-line positive and negative will look as fig. 2b.

fig. 2 a b

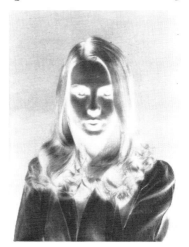
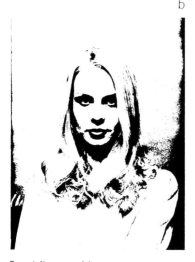

Semi-line negative Semi-line positive

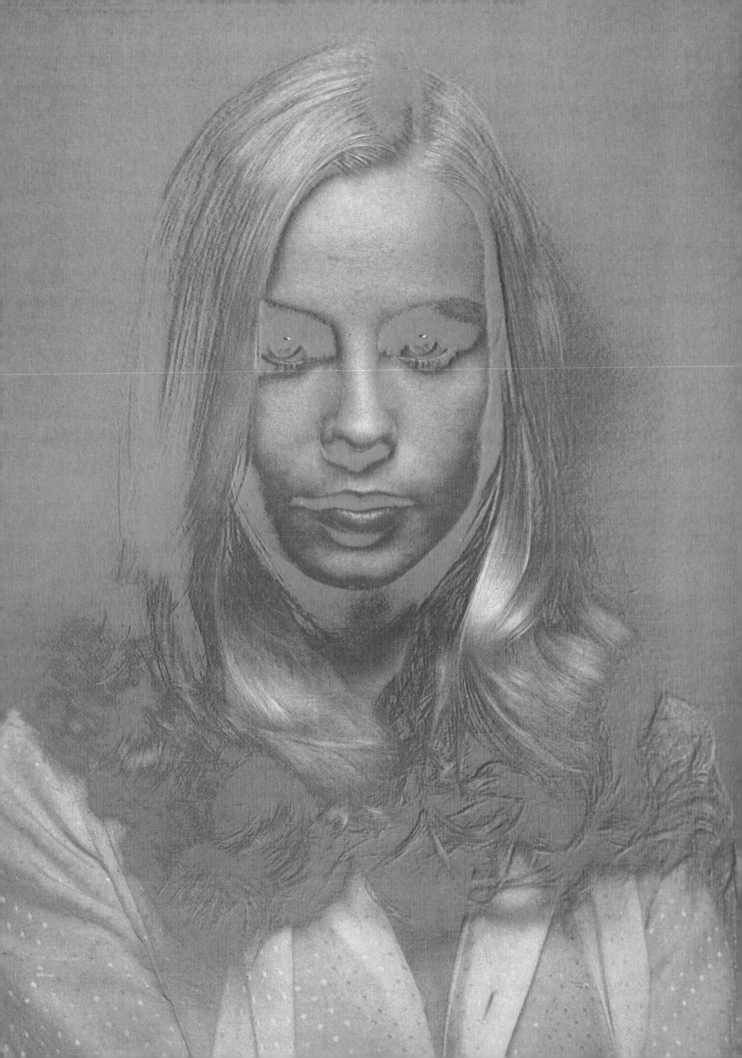

fig. 3

Pencil outline on white paper

Put the positive in the carrier and size it up to 10" x 8" in the masking frame and tape a piece of A4 white paper up to the stops; with a sharp pencil accurately trace the outline of the projected image (fig. 3).

Select a colour you think will suit the subject and use a strong filtration (160): the stronger the filtration the richer the colour on the final print. My own filtration for the positive was 160 cyan.

Make sure your processing drum is clean and dry and the colour chemicals are up to temperature: have a pair of scissors handy.

Turn out all lights and cut a sheet of 10" x 8" Ektachrome 14 paper in half and expose a test-strip. Place the test in the drum and close the lid, replace the unexposed piece of paper back in the packet and turn on the white light.

Take the carrier to the light-box and replace the positive by the negative: switch on the enlarger and register the projected image with the pencil outline on the base-board.

Alter the filtration slightly: I replaced 10 cyan by 10 magenta, so that my new filtration was 150C + 10M. Turn out the white light and take out the other half of unexposed paper from the packet and expose a second test. (The exposure is roughly the same). Place this test alongside the first test in the drum, close the lid, turn on the white light and process as in the manufacturer's instructions. Rinse and dry both the test-strips.

Write the exposure, filtration and overall size of the enlargement on the back of each test and take them into daylight or a room with good even lighting and assess the filtration for a final print.

You must take into account that the double exposure will affect the density of all the tones on the final result; therefore

to determine the exposure with complete accuracy is not possible; however the test exposures are a reasonable guide and will take a lot of guesswork out of the experiment.

Make the final double- exposed print. The negative is still in the enlarger so choose an exposure and filtration deduced from the negative test. Turn out the white light, take a sheet of Ektachrome 14 from its packet and make an exposure. Before placing the paper in the drum, nick off the top righthand corner with a pair of scissors as a guide for later printing. With the paper safely in the drum and the lid and the paper packet closed, turn on the white light.

Replace the negative with the positive; turn on the enlarger and match the projected image exactly to the outline tracing on the base-board. Decide on your filtration and exposure from the positive test and alter it if necessary.

Switch off all lights; take the paper from the drum and place it in the masking frame, making sure that the cut corner is still in the top right-hand and being careful not to move the masking frame.

Make a second exposure over the first, replace the paper in the drum and close the lid. With the white light on, process as you did the tests. Wash and dry the print and check its colour balance and density in daylight or good room light. Experiment with various densities by increasing and decreasing the exposures on both the negative and positive. The colour balance can also be altered by changing the basic colour just slightly; try adding just 5M to a blue to make it 'richer'.

Balance is the key, the print should have the correct density in the mid-tones in order that the colours produced by the combination of positive and negative are not too light or too dark.

Colour Posterisation

The posterised print is probably the most famous of all the experiments in the darkroom, the technique goes back many years; I have a photographic darkroom book printed in the 1930's with a formula that is still valid to this day.

This particular experiment has been taken a little further than usual. In the past, posterised prints were almost always black and white. Now, with the direct positive colour papers more readily available in darkrooms, the adding of colour has given a new and exciting dimension to the procedure. However, the basics of the process itself have hardly changed.

The principle is fairly straightforward: a photograph is broken down into three parts, a highlight, a mid-tone and a shadow. To achieve this, three line conversion positives are made, then printed in sequence onto positive Ektachrome 14 paper. Each positive is assigned a colour and filtered during the enlargement procedure. This will be fully explained under the heading 'In the Darkroom'.

On Location

Photograph in black and white despite the final result being in colour. Cross-lighting on almost any subject will suit the posterising process: catch the sun casting strong definite shadows in the early morning or late afternoon. Vary your photographs – try some with a figure, others of landscapes and local beauty spots. Use a deep orange or medium yellow filter to enhance cloud formations; in fact a storm situation suits posterisation.

Camera

I don't feel that any camera size smaller that 2¼" sq. will be suitable for this process: definition is most important so the larger the format the easier the whole procedure will become. However, I have seen work based on 35mm shots which were striking: they showed more evidence of grain, but in some circumstances this can give a hard graphic quality to the print.

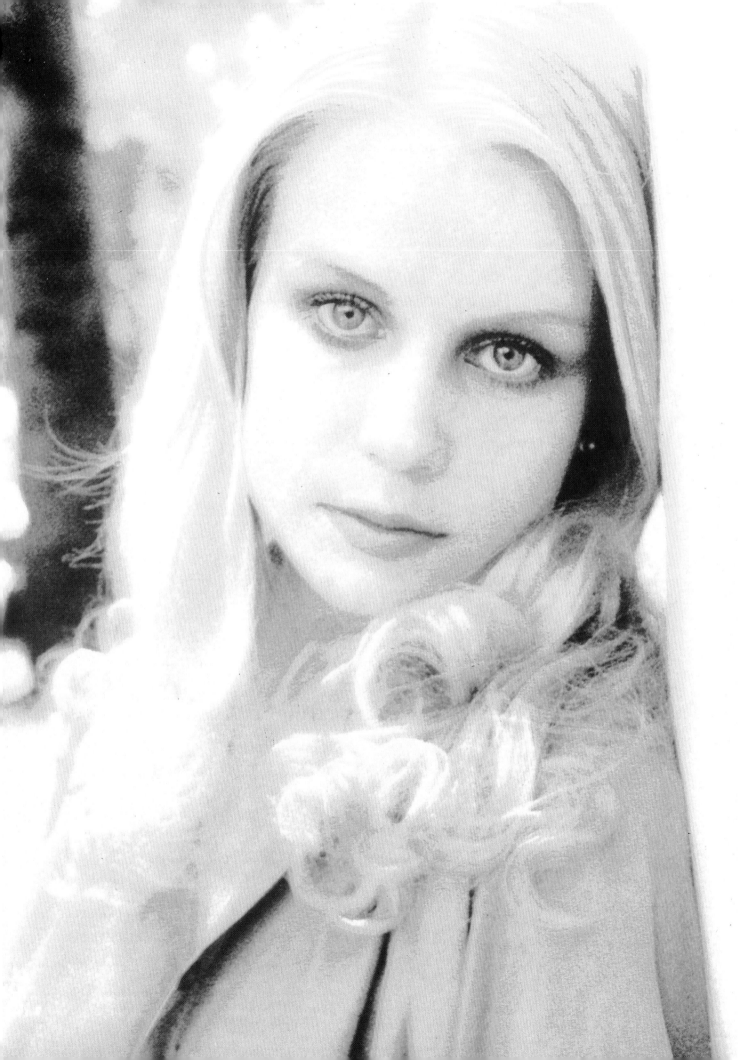

Load the camera with Tri-X or Plus-X, use an exposure meter and be accurate with your exposures. Expose about a dozen frames to give yourself a varied choice.

In the Darkroom

Develop the Tri-X in Microdol-X (undiluted) for 10 minutes at 68°F/20°C. If using Plus-X the development time is 7 minutes. Fix, wash for 10 minutes and hang the negatives to dry in a dust-free area. Make a set of contacts and select a suitable frame.

From the chosen master negative you require three line conversion positives. The larger they are the easier it is to get an acceptable result: (the illustration on page 121 was made using half-plate positives).

As stated we need three positives:
> one for the highlights,
> one for the mid-tones, and a
> third one for the shadows.

They need to be printed in sequence on top of one another so they have to be very accurate. It is important to mark the negative with 4 crosses as register marks, one in each corner, as in fig 1; these will be invaluable for accuracy in printing.

If you intend working to the larger format, such as ½-plate or 5" x 4" the 4 crosses on the master negative can be made in the rebate as in fig. 1. But with 2¼"sq. enlarger the crosses

fig. 1 Mark four crosses in rebate of negative

fig. 2 Cut four crosses in emulsion with scalpel

will have to be made just within the picture area as the carrier masks out the rebate in printing. I will describe the 2¼"sq. (6 X 6cm) contact method from now on.

Place the negative on a clean light-box, emulsion side up and with a scalpel, scratch a tiny cross in each corner (fig.2). If one or more of the corners is in shadow, i.e. the emulsion is clear, you will have to make the cross with opaque and a fine sable brush or a fine fibre tip pen – (fig. 3) If the final print is 10" x 8" format the crosses will mask off whether the final image is landscape or portrait (fig. 4).

The three positives have to be extremely accurate so when they are exposed they must be processed and dried together; also, to achieve the desired result the exposures must be stepped in the ratio: 1: 3: 5:, which makes the highlights, midtones and shadows. Pour out a small dish of Kodalith Super Liquid, 1 part A to 1 part B to 3 parts water at a temperature of 68°F/20°C.

Working by the appropriate red safelight cut a sheet of Koldalith 4556 film (5" x 4") in half and make a test-strip (contact) using the light from the enlarger with this timing: 1 sec, 3 secs, 5 secs. The aim is to get the middle exposure correct. Alter the stop on the enlarger if necessary to reach these timings. Obviously on some enlargers and in some conditions it is not possible to achieve 1, 3 and 5 secs. exactly, but as long as that ratio is kept (e.g. 2, 6, and 10 secs, or 3, 9 and 15 secs. etc.) you will achieve your objective. Expose and develop the test for 2¾

fig. 5
Test strip 1, 3 and 5 seconds

this middle exposure should be normal

thin / heavy

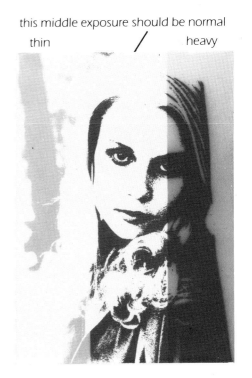

fig. 3

If edges in shadow make crosses with opaque and a fine sable brush

fig. 4

The crosses will mask-off at tne 10" x 8" format size

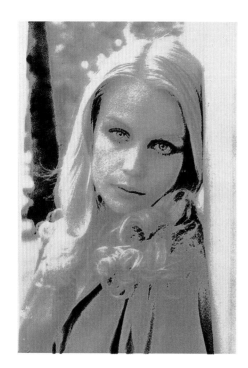

minutes at 68°F. Fix, rinse and dry the film.

Make a number of tests until you are satisfied that you have a normal line positive in the middle of the three exposures (fig. 5): that is, a line positive with a dense black, clear highlights, and a good number of steeply-graduated half-tones.

Expose and develop together three sheets of Kodalith 4556 film as dictated by the test. Fix, and wash for 2 minutes and hang each to dry naturally on a line, clipped from one corner only; this will prevent the films from stretching unevenly.

Take the three films to the light-box and with a fine sable brush and liquid opaque spot out any dust spots: they should look as figs 6A, B, C.

fig. 6 Photoprints

A B C

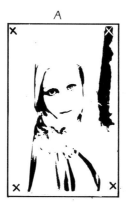 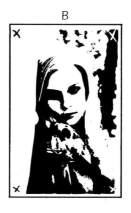 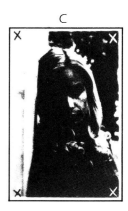

The Enlargement

The three positives have to be printed in sequence onto the Ektachrome 14 paper, each with its own filtration. It is possible to work with the three films in sequence in a carrier without glass, but it is difficult; therefore I suggest you use two pieces of clean 5″ x 4″ glass and make up a carrier.

Thoroughly clean one piece of glass and lay it on the light-box; place down the thin positive (6A) and tape it down one edge. Take the normal positive (6B), place it on top and manoeuvre it untill it is exactly on top, using the four crosses as a guide. Tape the front edge with Sellotape and make the hinge (fig. 7). Place the third positive, the heavy one (6C) on top, matching it exactly. Tape down the front edge again making a second flap (fig. 8).

Flap the top positive to one side and place the second glass on top. Return the made-up carrier to the enlarger and size the

fig. 7

Medium pos
Thin pos
5″ x 4″ optically flat glass

fig. 8

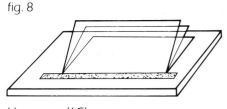

Heavy pos (6C)
Medium pos (6B)
Thin pos (6C)

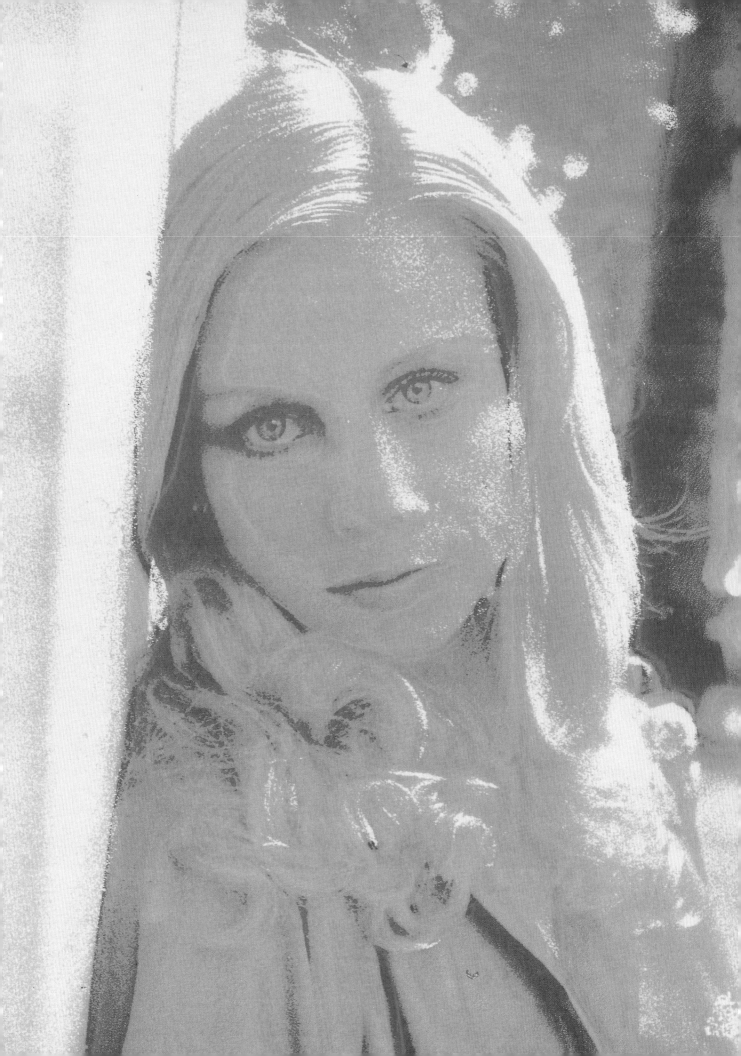

fig. 9

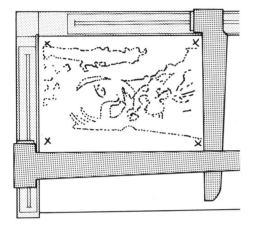

Pencil outline on A4 paper

projected image to 8" square. Tape a sheet of A4 paper to the stops of the masking frame and carefully trace with a sharp pencil the outline of your subject including the 4 crosses (fig. 9). You may find that you have light spill from this carrier so you must be prepared to block it off when printing.

Return to the light-box, flap the medium positive back thus leaving the thin positive in place: replace the cover glass, return the carrier to the enlarger and match the projected image to the trace again, using the four crosses for the exact registration.

Make sure you have ready a packet of 10" x 8" Ektachrome 14 paper, a rotary drum, colour chemicals in their separate containers and up to temperature, and a pair of scissors. Memorise the position of the scissors.

A test-strip, I find is of little help in the particular process. It is advisable to go ahead and attempt a complete print.

The three elements will need to be printed in an exposure ratio of 2: 4: 6.

Your first positive (the thin one) is in position. Dial in 160 cyan (or any colour you choose, simply bear in mind that all colours should be complementary), stop down to ƒ8, turn out the white light, take a sheet of Ektachrome 14 paper from its packet; expose for 2 seconds, and before you place the paper in the drum clip off the top right-hand corner with the scissors (this is a guide for later printing), close the lid and switch on the white light.

Return to the light-box, take off the top cover glass and flap the middle positive onto the thin one, checking that the four crosses still match: replace the top cover glass.

Return the carrier to the enlarger and match the projected image exactly to the tracing again, using the four crosses as a guide. Use 160 yellow filtration and turn out the white light. Take the paper from the drum and place it in the masking frame, making sure that the cut corner is still in the top right-hand and being careful not to move the masking frame expose for 4 seconds and replace the paper in the drum, closing the lid.

Return to the light-box with the carrier and remove the top cover glass and flap the third positive (the heavy one) onto the two others, checking that the crosses still match; replace the top cover glass.

Return the carrier to the enlarger, switch on and check that the projected image matches EXACTLY. Dial in 80 magenta. (This next exposure creates the highlights: with three combined exposures on the paper, the areas affected by the final exposure will go white if your exposures are sufficient; however, it is worth adding colour filtration because occasionally this third colour picks up in certain shadow areas thus giving a further dimension to the print).

Turn out the white light; take the paper from the drum and place it in the masking frame, again check that the clipped corner is in the top right-hand and make sure that you do not move the frame. Expose for 6 seconds, return the paper to the drum, close the lid and turn on the white light.

Double check that the chemicals are up to temperature and process as in the manufacturer's instructions. Wash and dry the final print and trim to a suitable composition making sure that the four crosses are eliminated.

Check the final dried print in daylight or in good room light. If the print is too light, cut the exposures; if too dark increase them, but remember to keep the correct ratio.

To get the three images to register exactly is quite difficult; however, a slightly out of register print can be accepted; if the registration is too far out you will have to go back and take even more care over matching the positives in the carrier and the projected images on the baseboard.

This is a splendid experiment, well worth the infinite patience and meticulous procedure required.

Moving Image

I found this experiment, which incidentally illustrates the cover of this book, taxing and time-consuming. Practice and patience in abundance are needed not only to get densities balanced but also to get the right feeling of movement from what is, after all, a still photograph.

Up to a point similar results can be obtained by direct photography using a slow shutter speed and varying the colour of the light source during the exposure, but it will be found easier to control and to have a far wider range of results if carried out, as here, in the darkroom.

A monochrome combination of negative and positive from the same source, (the original negative), bound together slightly out of alignment, is printed on to reversal colour paper (Ektachrome 14). A chosen colour filtration is set and during exposure the paper is moved across the baseboard at a given rate. At a chosen point the filtration is switched to another contrasting colour; at certain other points, too, the exposure is briefly interrupted: this is to avoid the final result looking too repetitive.

In the Studio or on Location

The choice of subject matter is fairly limited. Inanimate objects should be avoided if possible: a head, preferably in profile as in the example, or a family pet are good subjects. To simplify the experiment in the darkroom you need a white background. This would be easier to arrange in a studio as plain white walls are difficult to find whilst on location.

Make sure your model has a strong, well-defined profile. The hair is most important for this particular photograph; I believe it should be in the classical style: upswept and away from the face, in fact the Victorian 'bun' works very well for this technique. The make-up should be in keeping with the hairstyle, with extra attention being paid to the eyes. Keep the

foundation flat and avoid shine, particularly on the nose and cheekbones, by using facepowder.

Lighting and Exposure

Set your model up in profile in front of a plain white background; this should be lit with a flood or a spotlight, making sure that all the area behind the head is covered (fig. 1). Bring in a second floodlight and light the face. Check that the background spot kills any shadow cast by the flood. If you are on location and using a white wall make sure the sun does not cast a shadow, in fact choose a day when the light is soft and even.

Any camera format from 35mm upwards may be used: load with Tri-X or Plus-X film and use a tripod for stability.

Turn out the light on the background and take a meter reading with just the one light directed on to the head. Once you have established the exposure, turn the background light on again and expose about a dozen frames. Keep the shutter speeds as fast as possible to avoid movement effects of the model or the camera: although this is an experiment about movement and the final result looks blurred the key to a good result is a sharp original negative.

fig. 1
Single spot on
to the background

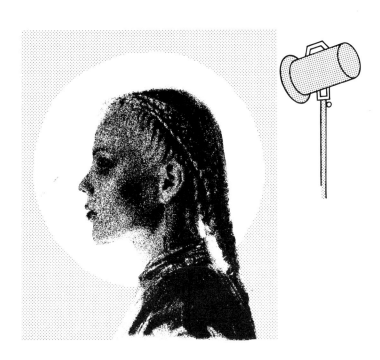

fig. 2

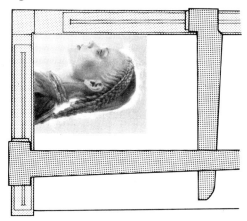

2" wide with 5" x 4"

fig. 3

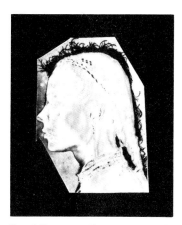

Semi-line negative

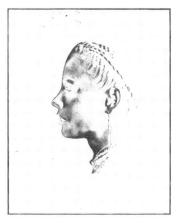

Semi-line positive

In the Darkroom

Develop the Tri-X in Microdol-X (undiluted) for 10 minutes at 68°F/20°C. If you are using Plus-X the development time is 7 minutes. Agitate for 15 seconds every minute to ensure even results with good mid-tones. Fix, wash for 10 minutes and then hang to dry naturally in a dust-free area.

Make a set of contacts and select a suitable frame. If you are using a 35mm camera enlarge the selected image to 2" wide (fig. 2). If you are using 2¼" sq. (6 x 6cm) the next two operations are best done by contact to retain the maximum of definition. This work is carried out by a red safelight.

Cut a sheet of Kodalith 4556 film in half and make a test-strip. Develop the test in Kodak DPC print developer (not the Super Liquid recommended by Kodak) diluted 1 to 9 at 68°F. for 2¾ minutes. Fix, rinse and dry the test and view over a light-box. The test will show a bright hard positive with steeply graduated mid-tones.

Select what you judge to be the most suitable exposure and make your final and complete positive in the same way as the test using a whole sheet of 5" x 4" film.

From this positive you need a bright hard negative, however it should not be as contrasty as a line conversion negative. Try to retain some of the mid-tones by developing in the same DPC developer for two minutes as used for the positive. (It is possible, if working from an original 2¼" sq. negative, to dispense with this stage. The negative itself can be used – it will give maximum quality and sharpness.

Expose a second sheet of 5" x 4" Kodalith 4556 film (the exposure should be roughly the same) by contact, emulsion to emulsion, to retain the maximum definition. Fix, wash for 2 minutes and dry: again check over a light-box and make sure that a good proportion of the mid-tones are retained. You should now have a positive and a negative along the lines of figure 3. Take both films to the light-box making sure that it is clean, dry and dust-free. You will need two pieces of clean flat glass to use as a carrier for the enlarger. Clean one of the glasses thoroughly and Sellotape it to the light-box. Tape the negative (the correct way round) to the glass making sure that the dust has not been trapped between negative and glass. Take the positive and register it exactly on top of the negative so that the image virtually disappears. Then:- move the positive slightly to right or left until a fine clear line appears outlining the face (fig. 4). When you have the two pieces of film in posi-

tion, place a clean weight on top and carefully Sellotape along one edge to secure the two pieces of film to the glass. Place the second sheet of glass on top, again making sure that dust has not been trapped between glass and film. This is the master to print from. (The same effect could be achieved in the studio by lighting the head with a rim light projected from the back and the figure set against a black background; but be warned, it is very tricky to get the lighting correctly balanced, and the highlight created by the rim light can cause the sharp lines of the profile to 'break-up').

The next step is to practise the movement of the image across the baseboard and this is best done, for economy, with black and white material. Use the back of an old 10" x 8" print (un-trimmed), and place it on the baseboard, not the masking-frame, in a landscape position and size the image up to about 4½" deep.

Next decide just how far across the paper you wish the move-ment of the image to extend: I suggest 6"- 7". Take a 24" ruler and place it on the baseboard butting up to the piece of paper. Use a sharp pencil to trace the projected image which should be centred top and bottom of the 10" x 8" and about 1½" in from the left (fig. 5). Tape the ruler firmly to the baseboard. With the ruler and the paper in position tape a piece of cardboard at 90° to the ruler on the right-hand side of the paper to act as a stop (fig. 6). Push the paper to the left until the image is 1½" from the right of the paper and then trace off a further image. Tape a second piece of cardboard to the edge of the paper (at 90°) on the left hand side to act as a second stop (fig. 7). Make sure that the two pieces of cardboard and the ruler are taped firmly and squarely to the baseboard and that the piece of paper slides easily from stop to stop, (right to left).

Since the test will be on bromide paper this stage can be per-formed by yellow safelight. Stop the enlarger down as far as it will go to give yourself an exposure time that is as long as pos-sible and which will give you more control. Then switch off the white light. Make a test-strip and develop in DPC print de-veloper (1: 9) for 1½-2 minutes at 68°F. Fix, rinse and dry the test. You will have a negative result – a black image on a white background the opposite of what you will achieve on your final colour print on reversal paper.

Determine the exposure from the test (it should be at least 10 seconds). Place a sheet of bromide paper square to the ruler and the stop on the right-hand side and expose for 10 sec-

fig. 4

pos/neg sandwich

fig. 5

Trace off image 1½" from left

fig. 6

Cardboard stop at 90°

fig. 7

Second cardboard stop at 90°

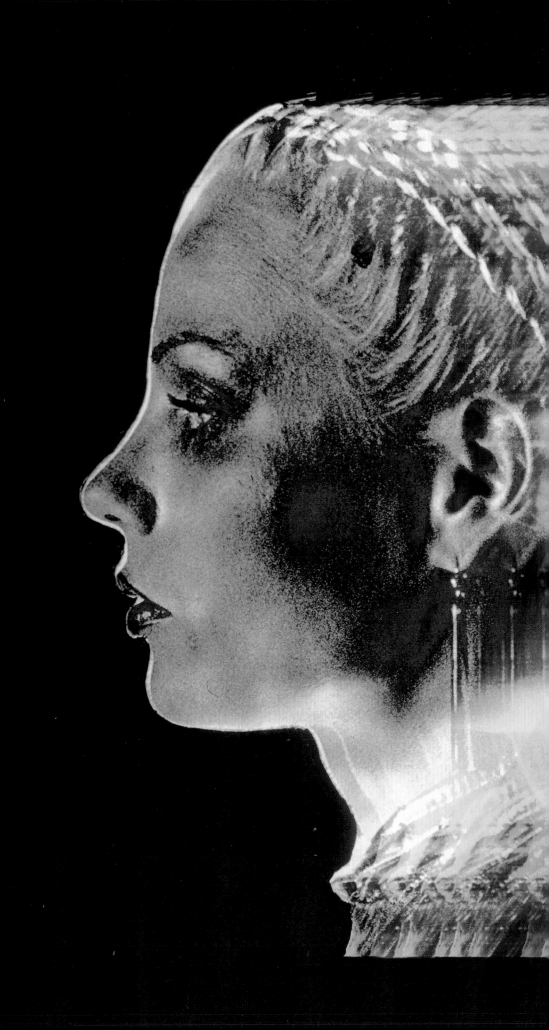

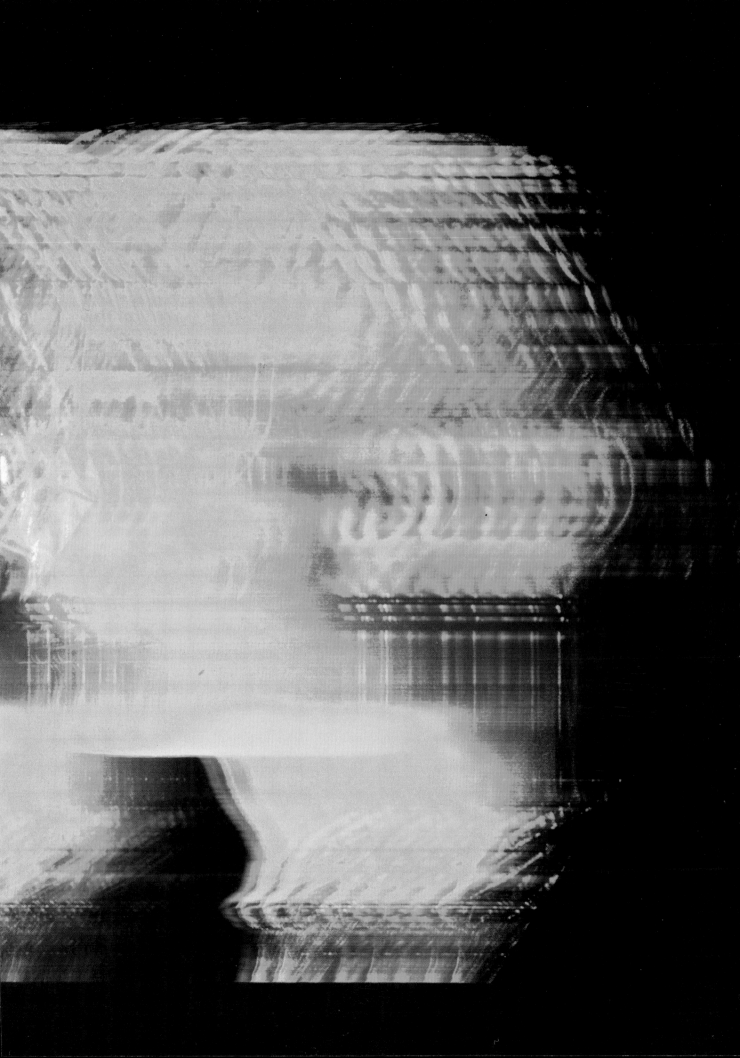

onds (assuming that this is the correct exposure determined from the test). Push the paper ¼" to the left using the ruler as a guide and expose for 3 seconds.

Push the paper a further ¼" to the left and expose for a further 3 seconds. Repeat this operation at ¼" intervals until you reach the stop on the left hand side. Process the 10" x 8" print in DPC developer as the test, fix, rinse and dry. You should have an image that looks like fig. 8. Although this bromide print is ideal as an exposure guide, I find two things wrong with this image:-

1) the movement across the paper is too regular and uniform, and
2) the face has a number of ghost images on it.

It will be necessary to experiment with a second series of exposures, on bromide paper, using the first print as a guide; but first a print dodger (as shown in fig. 9) should be made from thin wire and black card.

Take a second sheet of 10" x 8" bromide paper set to the stop on the right-hand side and make the first exposure on the left-hand side. Before sliding the paper to the left for the next exposure, mask off the front of the face with the dodger (fig. 10) but note that only this half of the face needs to be covered. The next three or four exposures must overlap this first one on the head, but only at the back of the head and neck, not in the face area: this is why holding back with the dodger is so important.

fig. 8
B/W photoprint of movement

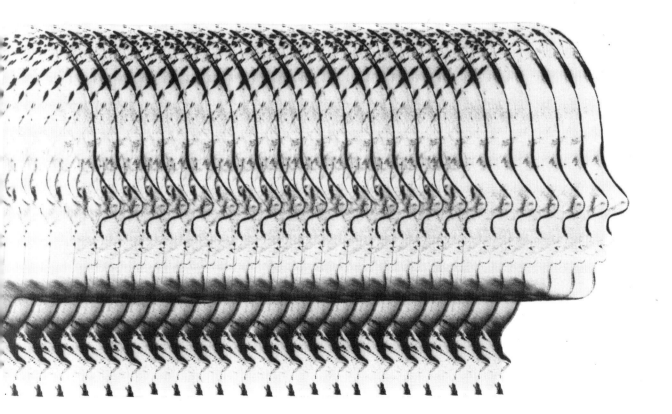

In my own experiment, as I moved the paper across I made some of the steps irregular, varying between ¾" and ½", and half-way through the series of exposures I left a gap of about 1". This worked for my image but it is really a question of personal choice. You could attempt to slide the paper across (with the enlarger lamp left on) in a continuous movement. This gives a much more comprehensive blurred effect and certainly works well on some subjects. Try a mixture of both; a few steps and then a blurred section. It is well worth two or three pieces of paper to get the right balance. The sizes and measurements I have given can only be a rough guide; the size of the image and the amount of movement can only be judged by testing each individual subject.

Once you have a black and white image that satisfies, rinse and dry it and immediately write on the back the exposure time for the first main exposure and the subsequent exposure times whilst moving the paper across the baseboard. (Although they will not be the same as those when using Ektachrome 14 paper, they will be relative).

The next stage is to practise the change to coloured filters part way through the exposures whilst moving the paper across the baseboard. If you have an enlarger with dial-in filtration, it will make the procedure much easier. With the filter tray system it is slightly trickier. I chose blue for the first exposure of the full face and yellow for the movement. You can if you wish use a number of colours, it makes the procedure more complicated, but it can certainly lead to a spectacular result.

fig. 9

Dodger made of thin wire and thin black card

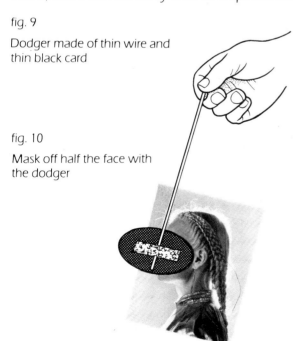

fig. 10

Mask off half the face with the dodger

Begin with the highest filtration of a single colour in the drawer as possible; this will give bold, pure colours. In my own case to achieve the illustration I dialled in 160C.

Next practise with a piece of 10" x 8" paper in total darkness until you can get it right without dropping anything or forgetting the exposure sequence. Before you turn out the white light line up everything you will need on a bench and memorise exactly where they are. The dummy run goes thus:-

1) Butt the piece of 10" x 8" paper up to the right-hand piece of the cardboard and the ruler.
2) Set the filtration, (160C or your chosen colour).
3) Turn out the white light.
4) Expose for 10 secs. – the first exposure.
5) Change the filtration to 160Y or your other colour chosen. (This is quite tricky in the dark so you will have to devise a method in you own conditions.)
6) Before you move anything else pick up the dodger and cover the lens with it.
7) Move the paper a ¼" to the left.
8) Switch on the enlarger and quickly move the dodger until it is covering most of the head and expose for 3 seconds.
9) Keep the dodger in position and move the paper a further ¼" to the left and make a second exposure (3 secs.).
10) Repeat this another three or four times with the dodger in position until the moving image clears the back of the head.
11) Take the dodger away and continue pushing the paper to the left exposing every ¼" or so for about six more exposures. Then,
12) jump ¾" to 1" to give a gap before continuing with more ¼" gaps until you reach the cardboard stop on the left.

This will give you an image approximately as illustrated. If you have decided from your own black and white tests to vary the gaps and the movements from the sequence I've shown, still practise with dummy runs in total darkness until you have it move-perfect. Once you are satisfied you can get your sequence correct in the dark, make two test-strips on Ektachrome 14 – one of the head with blue filtration and one of the head with yellow filtration (with no movement). Process, rinse and dry the tests, working to the manufacturer's specifications. Write on the back of each test the filtration and the exposure.

Thoroughly wash and dry the rotary drum, pour out fresh colour chemicals and bring them up to temperature.

Turn out the white light and expose a final multi-exposure print as practised. Place in the drum, close the lid, ensure that the packet of paper is sealed and turn on the white light. Process as your tests dictate, wash and dry the print.

If the main head (in blue) is too dark in colour increase the exposure for this stage; if too light, cut it. Likewise, if the movement across the board is incorrect in density, make the necessary adjustments to the exposure during the successive moves. The colours should be well saturated and as pure as possible.

If you are successful with just two colours try a further experiment with several colours, starting bright and garish and finishing with muted, subtle colours.

If you are experienced in darkroom colour work, obviously ignore the black and white tests and dummy runs and go straight ahead working directly with colour stock.

Like many other experiments demonstrated in this book the possibilities are almost infinite and the result fascinating.

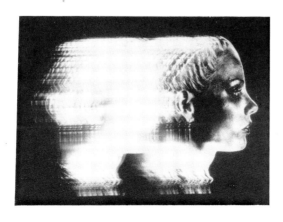

Polarized
Colour Silhouette

The delicacy of the colours contrasting with the hard black lines of the line conversion silhouette makes this particular experiment a fascinating exercise in design and photographic technique.

The final print is not so difficult to achieve as it would at first appear. It consists of a line conversion negative or reverse silhouette with a colour inset. The colour inset is achieved by using two polarizing filters in conjunction with two pieces of distorted film. A polarizing screen is placed immediately next to the light source of the enlarger, that is, above the carrier but as far from the lamp as possible; a second one is placed on the outside of the lens. If the screen on the lens is rotated so that its plane of transmission is at right-angles to that of the screen in the carrier, no light will pass. If a suitable material such as some plastics, certain fibres or chemical crystals, is placed between the polarizing filters – in the carrier of the enlarger astonishingly bright and pure coloured shapes will be projected. This experiment makes use of this quality, in conjunction with appropriate negatives, printed onto Kodak Ektachrome 14 paper.

One of the polarizing filters must be at least 2¼" x 2¼" sq. to cover the area of the carrier's aperture; the other large enough to cover the lens of the enlarger. You may well find it difficult to locate the larger size of 2¼" x 2¼". I bought mine from a shop selling radios, video and lighting systems but a good photographic dealer will be able to get it for you. The filter for the lens can be of the rotating type used on cameras.

A 2¼" sq. enlarger is the minimum size you can use for this experiment even if the original shots were made on 35mm. In fact the larger the format the more likely you are to get an acceptable result and 5" x 4" or ½ plate (the size I used) is ideal.

The illustration may be achieved as follows:

fig. 1

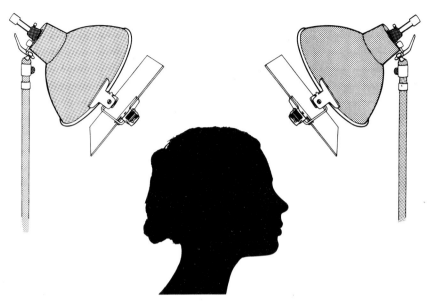

Light background only with two floods

In the Studio

Use a white projection screen as a background or paint a wall white. Make sure that your model's hairstyle is pinned up on top of the head, or in a chignon, to show the shape of the neck. Light the wall evenly with two floods or two flash guns and place your model about 1 ½ metres away in profile (fig. 1). Make sure that the only light source is that directed onto the background and avoid any light whatsoever on the figure, whether it is caused by daylight from a distant window or from even a small lamp.

Load the camera (2¼" sq. 6 x 6cm or 35mm) with Tri-X or Plus-X film. Make the image you will require on the final print as large as possible in the viewfinder and make sure the image is sharp – good definition at this stage is all-important.

If you are using two floods, stop down to *f*8 to get adequate depth of field. The shutter speed will be slow, at around 1/30 or 1/15 of a second, so make sure the camera is on a firm tripod to avoid movement.

With flash, movement is eliminated to a great extent and a much smaller stop can be achieved (*f*16 or *f*22); however flash does tend to bounce around walls and ceiling reflecting light onto the form and the side of the figure, thus breaking up the silhouette, so it must be used with discretion. When the lighting and the model's pose are to your liking, expose a complete roll of film to give yourself a wide choice of images.

fig. 2

Tape across with red lith. tape or shape with liquid opaque and sable brush

fig. 3

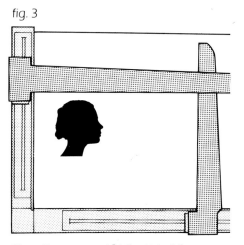

Size silhouette to 1¾" within 2" square

In the Darkroom

Develop the Tri-X for 10 minutes in Microdol-X at 68°F/20°C or Plus-X for 7 minutes. Fix for 5 minutes, wash for 10 minutes and then hang to dry naturally in a dust-free area. When the negatives are dry, make a set of black and white contacts and select a suitable frame. Take the chosen negative to the light-box and, if you are using a full head shot as illustrated, isolate the head by taping across the neck with a piece of red lithographic tape as in fig. 2. Originally with silhouettes it was customary to shape this bottom edge; this can still be achieved with opaque and a fine sable brush. Although this negative will provide the reverse silhouette when printed, as it is in continuous tone, the result will not be hard enough. Consequently it will be necessary to make a line negative from this.

Place the negative in the enlarger and size the silhouette to 1¾" on the masking frame (fig. 3). Change the safelight to red and cut a sheet of Kodak Reproduction film 4566 (½ plate or 5" x 4") in half and expose a test-strip, (fig. 4). Pour out a small dish of Kodalith Super Liquid developer, 1 part A, 1 part B to 3 parts water at a temperature of 68°F. Develop the test for 2¾ minutes, fix, rinse and then dry. Assess the exposure from the information given by the test and then expose a complete sheet of film. Develop as the test, fix, wash for 3 minutes and then dry.

When the film is dry take it to the light-box. It will be a hard line conversion positive silhouette as in fig. 3. Spot out any dust marks with opaque and a fine sable brush.

Return to the enlarger and make a contact reversal onto Kodalith film 4556 (the exposure should be roughly the same) and develop for 2¾ minutes at 68°F in the Super Liquid developer, then fix and wash. This provides your master line negative. Before you turn on the white light, take two pieces of the same film unexposed and put them in the fixer for 2-3 minutes. These will be used, when prepared, to provide the polarized light pattern. When they are completely clear, place them in the wash with the negative. After 5 minutes add a drop of wetting agent and hang the three films to dry, making sure you keep fingermarks and dust off the clear films in particular. When the three films are dry take them to the light-box. Spot out any dust marks on the negative with opaque and a fine sable brush.

fig. 4

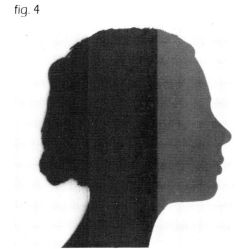

Test strip on Kodalith 4556 film
2, 4, 6 and 8 seconds

fig. 5

Lay a sheet of clear film (4556) on a hot
iron and distort it

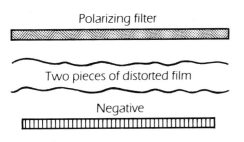

Polarizing filter

Two pieces of distorted film

Negative

For the next stage you need a clothes iron, a sheet of clean glass at the size you are working, a sheet of similar size polarizing filter, the negative, and two pieces of clear film.

Clean the light-box and the filter thoroughly. Place the polarizing filter flat on the sheet of glass and tape them together along the edges; lay this glass-side up on the light-box. Place the negative on the glass and tape it down firmly along all four edges.

Set the iron to its coolest setting and when it is up to temperature lay one sheet of the clear film on the hot surface (fig. 5). It will distort and buckle; when cool, tape it on top of the negative. Lay the second sheet of film on the hot iron and when that has distorted, lay that on top also but across the first sheet at right-angles, and tape it firmly down. If you now look through your second polarizing filter and twist it you will see the colour effect intensify and then almost disappear. Obviously it is when the colours are at their most intense that the second polarizing filter is in the required relationship to the first. Note, however, if you are not using 4556 lith film but some other type, the polarizing effect may not occur. In this case it is worth experimenting with other materials previously mentioned. Certain types of clear kitchen plastics, especially that thin kind used for the wrapping of meat, some plastic bags, and small sheets of acrylic will work very well; the effect is enhanced if the material is distorted by twisting, crumpling or heating.

fig. 6

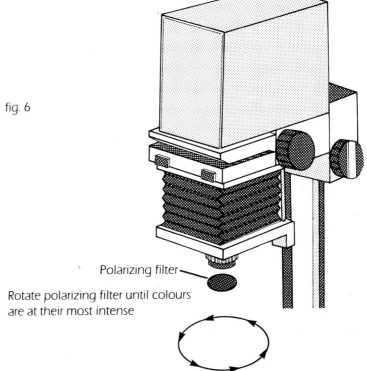

Polarizing filter

Rotate polarizing filter until colours
are at their most intense

Polarized light patterns can also be achieved through some artificial fibres, or certain chemicals when crystallized. It would however be necessary to experiment at some length with these.

Place the glass with its polarizing filter, negative, and two pieces of distorted film in the enlarger with the polarizing filter uppermost i.e. towards the lamphouse. Switch off the white light and enlarge the silhouette to 10" x 8". Place the second polarizing filter on the enlarging lens and turn it until the colours are at their most intense. Tape the filter into position and stop all the way down. The filters and the film should be in the sequence shown in fig. 6. Check that no white light is spilling out of the gap by using black paper and masking tape.

Pour out the colour chemicals and bring them up to temperature. Expose a test-strip onto Ektachrome 14 paper and process as per the manufacturer's instructions. Dry the test and check it in good light before exposing a complete 10" x 8" colour print which should then be dried and inspected in a good light. The intensity of the colour can be varied by increasing or decreasing the exposure and many more varied colours can be achieved by adding filters; but if filters are used the print becomes predominantly one colour (fine for some subjects) but I prefer the 'natural' colours achieved without filtration. Mount the final print on card.

Extra
Dimension

This experiment, based on the polarized silhouette technique described on page 138, achieves a kind of photographic surrealism – a Dali-esque fantasy – and has limitless possibilities. In the example shown the human figure, the common element in all the experiments, makes a particularly suitable subject; the peculiar 'depth in two dimensions' that results shows up extremely well: there is depth to the body and to the skin producing an effect that is curious and remarkable. Remarkable not only when viewed, but remarkable in that the final result more than justified the steps I took to reach it.

I knew that by photographing a figure against black and putting black patches on it I could achieve a figure floating in space apparently with holes through it. It also occurred to me that by double printing I could have an amorphous background, not only behind, but also showing through the figure. I then perceived that by adding a shadow to the skin I could get a 'second depth' to the figure and this was eventually achieved with a lith negative in conjunction with all the other elements after experimenting in the darkroom.

In the Studio

The first problem to overcome was to get a 'depth' to the skin. Only part of the solution can be resolved in the studio, some work must be done in the darkroom. However this studio work must be done first for the experiment to work as a whole. The studio problem was solved thus:-

I started by putting black discs of various sizes onto the figure and then photographing the figure on a completely black background. But note: the black discs must be on the figure at the shooting stage. Do not attempt to put the discs on the figure at the transparency or any other stage, as it is well nigh impossible to get the perspective right.

I simply cut out of 2 inch wide black masking tape various-sized circles and stuck them in a random fashion onto the model. If you are unable to obtain this kind of tape (used by the film industry to tape up their film cans), use thin black paper backed with double-sided tape. Make sure that the circles are accurately cut (use a compass with a sharp white pencil to mark the circles) and once cut, make sure that you can stick the circles to the skin and peel them off again without causing discomfort to the model (fig. 1).

The background the figure is against must be completely black. Ideally use a piece of black material with a matt, not shiny, finish that will soak up and not reflect the light. Alternatively if a large piece of material cannot be found, you can paint a wall and a sheet of 8' x 4' hardboard with a roller and matt black paint. If this hardboard is placed on the floor and butted up to the background, it should cover the whole of the figure.

Lighting

The lighting was achieved with a flash unit which I decided to use because it was essential to get the figure completely in focus from front to back. With the extra amount of light produced by the flash the lens could be well stopped down to achieve an acceptable depth of field, at least $f16$, ideally $f22$. The flash had no umbrella or fill-in, giving a harsh light with strong deep shadows (fig. 2). The faster Ektrachrome 200 film I used also enabled me to use the smaller aperture needed.

The light source was kept high to simulate sunlight, making sure that the light from the flash covered the whole of the figure and did not fall-off at either end making a hot-spot which must be avoided. This usually occurs when the flash unit is too close. I moved it up and away until it adequately covered the subject.

fig. 1

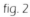

Stick black discs (circles) on the model

fig. 2

Flashgun lighting without diffuser
Model to be on black background

Cameras

The larger the camera format the easier this particular experiment becomes. I used a 2¼" sq. (6 x 6cm) but a 35mm camera could have been used equally as well to provide the initial transparency to work from, and this can be enlarged to make the line negatives you require, so do not let the consideration of format size put you off.

The Set-up

I posed the model and placed the discs roughly in position. Once the pose and the lighting were to my satisfaction I checked through the camera and made my final arrangement of discs, trying to avoid flare as much as possible. The black discs need to be completely black. If there are any flare spots, spray the discs carefully with dulling spray or wait for the results of the transparencies and then retouch them.

Exposure and Transparency Processing

The exposure was calculated with the meter designed for the flash unit and it was strictly adhered to. Two rolls of film were exposed; this gave a wide and varied choice. The aesthetics of this particular photograph must be correct; pure technique will not see it through, so give yourself a wide range of transparencies to choose from.

The film was sent to a reputable colour laboratory dealing with the E-6. process. Despite all my precautions during shooting some of the discs gave off flare from the lights, and needed retouching.

In the Darkroom

I placed the chosen transparency on a light-box and with a linen tester and the finest of sable retouching brushes I spotted out with black dye the offending white highlights. Parts of the background were not completely black so I retouched these at the same time. The object is to make all the black areas completely black.

From this finished transparency a black and white negative is required. The result needs to be harder and denser than normal so I contacted the 2¼" sq. transparency (emulsion to emulsion) to a sheet of 5" x 4" Kodak Plus-X Pan film 4147 with a sheet of glass on top to make good contact, working in complete darkness (fig. 3).

The exposure was determined from the enlarger's light source and as enlargers are so varied you will have to make a test-strip. My test was developed in a small ½-plate dish using Kodak DPC Developer diluted 1 to 9 at a temperature of 68°F/ 20°C for 2½ minutes with constant agitation, fixed, rinsed and then dried. A check over the light-box led me to choose the exposure with a clean background and good solid blacks. I then exposed and developed a complete sheet of 5" x 4" Plus-X. It was fixed, washed for 10 minutes and then dried with gentle heat in a drying cabinet. From this negative I needed a line-conversion negative so my next step was to make a line-conversion positive.

The larger the format of this intermediate positive, and therefore the final negative, the easier it is to get an acceptable result. (Again if you do have a small format enlarger do not let this consideration deter you too much, the experiment is still possible, just trickier). However I do not think it feasible to work in the darkroom at a smaller negative and positive size than 2¼" sq., so if you started with a 35mm transparency this should be enlarged to 2¼" for the first negative on Plus-X, and all subsequent work carried out at this size. Of course, if you have the facilities, proceed as for the 2¼" sq. instructions. I worked on a ½-plate enlarger and this was the procedure:-

The 2¼" sq. negative was projected onto the masking frame set at 6" x 4" with a ¼" border. The image was comfortably enlarged within the 6" x 4" area (I took into consideration that the figure would eventually 'float' in a coloured background and that background was in fact an important element of the whole concept) and the enlarger lens was stopped right down to ƒ22. After checking that the safelight was red a small dish of Kodalith Super Liquid developer was mixed (1 part A, 1

fig. 3

Glass

2¼" square transparency

5" x 4" Kodak plus X film 4147 emulsion down

baseboard

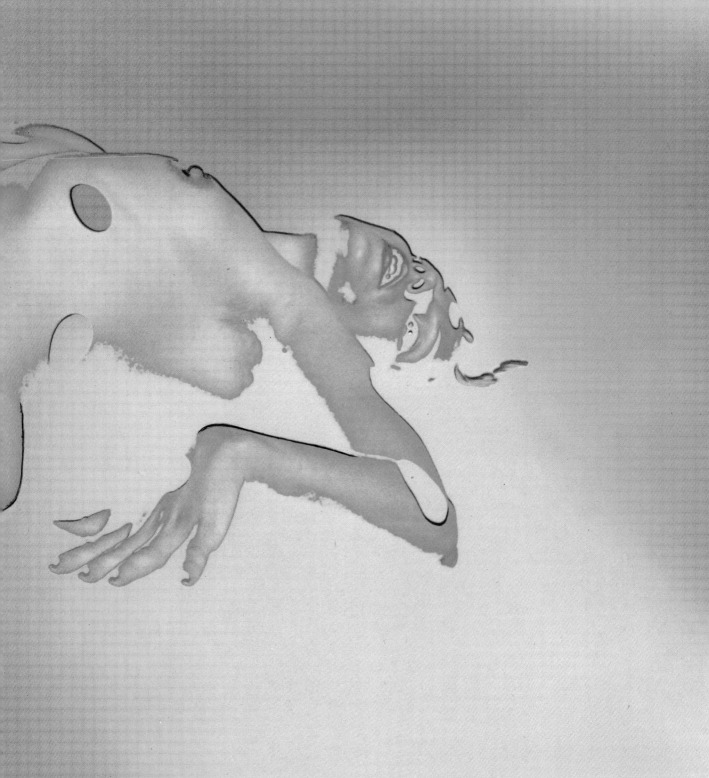

part B to 3 parts water at a temperature of 68°F/20°C.

A test-strip was made from half a sheet of ½-plate Kodalith Ortho film 4556 and developed for 2¾ minutes, fixed, rinsed and dried. Once the exposure had been determined by checking the density of the blacks and the clear highlights, a complete sheet of 4556 film was exposed and processed as before.

When dry, the finished line positive was taken to the light-box and all dust spots were filled in with a fine sable brush blocking-out medium.

With a clean sheet of heavy glass to ensure a good contact, the line positive was printed onto the other half of the ½-plate sheet of 4556 film in exposure steps to provide a test-strip. It was developed for 2¾ minutes., fixed, rinsed and dried as before. The step which showed the black areas as completely opaque while the clear areas were completely clear, was chosen for the final contact exposure time onto a complete sheet of ½-plate 4556 film. It was fixed, washed for 3 minutes and dried. This final line negative was then carefully spotted, as the line positive had been to ensure that its black areas were completely black and the clear areas clean and totally free of marks or dust. This is where the larger format of ½-plate or 5" x 4" is a bonus; it is much easier to keep clean. It was immediately put into a negative bag and filed.

My next task was to print the double colour print onto R14 paper. To get the figure 'floating' (as per the illustration) I decided to use the 'polarized' background as in experiment 19. The line negative was used to hold back the area for the main figure on the background and also to create the shadow around the holes in the skin. I made my final double exposed colour print thus:- First the line negative was sized up in the 10" x 8" frame allowing a reasonable amount of clear background around the figure, but this clear background filled the complete area of the mask. The enlarger was locked and with a sharp pencil the projected image was accurately traced onto a sheet of A4 paper taped up to the stops of the baseboard. Particular attention was paid to the 'holes in the skin' (fig. 4).

Two colour test-strips were made. One for the main figure and one for the background. Firstly the figure:-

The master 2¼" sq. transparency was re-sized up exactly to the tracing on the baseboard, the enlarger stopped down to ƒ11 and 35Y filtration was dialled-in as the filtration advised

fig. 4

Trace projected image accurately on A4
white paper

on the packet of Ektachrome 14 paper.

With the white light out, a sheet 10" x 8" paper was cut in half
and a test-strip with three separate exposures (5-10-15 sec)
was made and then placed in the rotary drum, the lid closed,
the remaining half of the 10" x 8" sheet returned to its packet
and the white light turned on.

With the next exposure, that of the line negative, the proce-
dure was the same as the line silhouette with polarized colour
inset as on page 141 but this time using only the negative to
provide the polarized colour and discarding the two pieces of
distorted film. (Note: if you are not using Kodalith 4556 film
but some other make you may not get a polarizing effect; you
will have to locate a sheet of clear plastic or other suitable
material and use that in conjunction with the negative). The
$\frac{1}{2}$-plate line negative was placed in the carrier with a sheet of
polarizing filter ($\frac{1}{2}$-plate) taped on top making absolutely cer-
tain that all surfaces, film, glass, and filter were free of dust and
marks. The carrier was placed in the enlarger and the filtration
dialled back to zero. The $\frac{1}{2}$-plate negative was then reduced
exactly to the tracing on the baseboard. A second polarizing
filter was placed onto the enlarging lens, the enlarger
switched on and the filter twisted until the colours were at
their most intense. It was then taped firmly down into that
position and the lens stopped right down (fig. 5).

With the white light switched off the other half of the 10" x 8"
sheet of paper was exposed as a test-strip with zero filtration
and three exposures of 20-40-60 seconds were made. This
was then placed alongside the first test-strip in the rotary
drum.

fig. 5

Polarizing filter

Optional plastic or other material if required

Negative

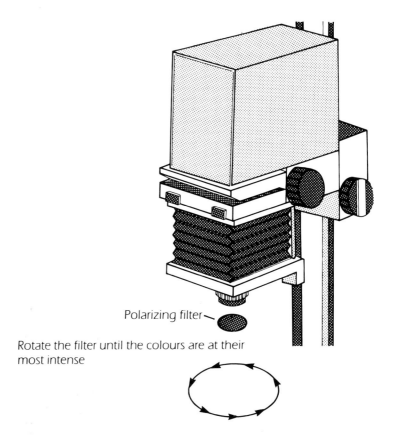

Polarizing filter

Rotate the filter until the colours are at their most intense

With fresh chemicals, at the correct temperature, the two tests were processed and dried as per the manufacturer's instructions

The exposures and the filtration were assessed from the tests: the rotary drum thoroughly washed out, dried and fresh chemicals and a pair of scissors were made ready.

The negative, with its polarizing filters, was still in position and with the white light out it was exposed onto a 10" x 8" sheet of paper for 40 seconds at f22. Before being placed in the drum the top right-hand corner was cut off to mark it for later printing. With the lid of the drum closed, the white light was switched on and the 1/2-plate negative was changed for the 2 1/4" sq. transparency and the filtration and exposure (calculated from the test) was set: 35 seconds at f11 and 30Y filtration. The polarizing filters were of course removed. The figure on the 2 1/4" sq. transparency was then sized-up exactly to the tracing on the baseboard. Then came the most important part: the baseboard was twisted, just a fraction, approximately at the centre point. This gave the holes in the skin their shadows and one of the two 'depths' mentioned at the beginning. I used the black discs as a guide (the more accurate the tracing, the easier it is to get the 'shadow depth' correct).

Once satisfied that the shadow would be correct and with the white light out, I took the 10" x 8" sheet of paper from the drum, checked that the cut corner was in the top right-hand when placed in the masking frame, being extra careful not to move this, and then made my second exposure on top of the first.

Fresh chemicals were poured out and a final print was processed as per the tests. The print was washed and dried and then assessed for balance. The balance is all important, the figure must 'float' in a pure colour background that complements and does not detract from it. The 'shadow' of the skin must also be correct.

To get all three elements correct first go is quite tricky so do not expect a first-class result first time. Be prepared for a few attempts, but when you do get it right you will find that all the effort and time expended is well worthwhile.

Technical Data

Agfachrome Speed

'The simple one-sheet, one-bath process'
Agfachrome Speed has put an end to the use of complicated chemistry that one normally associates with colour photography. Instead of 3 - 4 baths you now need one bath which you can use at room temperature.

The Agfachrome Speed process is a colour diffusion transfer process in which the entire operation takes place automatically in the layers of the single-sheet paper. After only 90 seconds you can appraise your print to establish whether you need to change the exposure or filter values used.

How to make your Agfachrome Speed print

In bright light
Place the slide, coating uppermost, in the film carrier. Because Agfachrome-Speed is a one sheet colour diffusion process, it has to be exposed through the back of the material. This is why the transparency has to be reversed, with its coating uppermost in the film carrier. You can tell which side of the transparency is coated from its relief-like surface viewed from the side.

Set the three colours on the colour mixing head to the paper's recommended basic filtration (see pack label). This produces a "basic copy" from which you can tell what colours, if any, need filtering.

Set exposure time. Exposure time is calculated by making phased exposures. A plus for Agfachrome-Speed – you save test strips. When appraising, remember that Agfachrome-Speed is a reversal material, so the longer the exposure, the lighter the print, and the shorter the exposure, the darker the print.

In complete darkness

Put the Agfachrome-Speed paper reverse side up in the enlarger frame and expose. The back can be recognized by its smooth dark surface. If you expose the white side by mistake, just turn the sheet over and re-expose – nothing will have been wasted!

Put the sheet in Activator N (90 seconds). Place the exposed Agfachrome-Speed with the back facing down in a dish or facing outwards in a drum. The image is developed and stabilized in the Activator N. Remember – in a dish the Agfachrome-Speed sheet must be agitated for the first 15 to 20 seconds. In a tank agitate throughout activation. After 90 seconds you can switch on the light.

In bright light

Place sheet in wash (5 minutes). The colours continue to build up during the wash, all the layers reacting at a uniform rate.

Appraise print. An exposure and filtration estimate is possible after just 90 seconds of washing. The print darkens slightly during drying.

Drying
Dry with hair dryer or fan heater for about 10 minutes. Dry both sides well, otherwise the coating may stick.

Courtesy AGFA

Kodak Ektaflex

This very much simplified process for making colour prints from colour negatives or transparencies was introduced by Kodak in 1982. It is based on the image-transfer process used in Kodak instant colour film, and it employs a single activator solution in conjunction with a compact print-making machine. The cost of the printmaker is under £100 and the outlay should prove well worth-while for any amateur who makes a regular practice of colour printing at home. At present it is limited to a maximum size of 8" x 10" prints.

The negative or transparency is placed in the enlarger holder emulsion side up because the image is transferred in processing. The starting points for exposure times, filtration and lens aperture are given with the materials. Exposure is made by suitable safelight or preferably in the dark, onto Ektaflex PCT Negative film when working from colour negatives, and PCT Reversal film when employing colour transparencies. The film is code-notched to ensure that it is placed emulsion side up. A sheet of Ektaflex PCT Paper is placed on the paper shelf of the printmaker emulsion side down and the exposed film is placed emulsion side up on to the film loading ramp of the printmaker. It is then slid smoothly into the Activator solution in the machine where it soaks for 20 seconds. The film sheet is laminated to the paper 5 seconds before the soak time is up by turning the handle at the side, and this is continued until the sandwich emerges. After 6 to 15 minutes, according to room temperature, they can be peeled apart. No washing is required and the print is damp-dry. It can be dried off very quickly with warm air from a print drier and, of course new prints can be made while others are being activated.

It is possible to experiment with solarisation and other creative effects by making a second print from the same sheet of film, being careful to ensure that multiple printing is not more than one or two seconds in order that there is no risk of contamination of the activator solution.

Since the developers and process control layers have been incorporated in the products the need for bleaching, fixing, stabilization, agitation and temperature control has been eliminated. The colour reproduction is excellent and comparable with that produced by conventional Ektacolor and Ektachrome papers. At present the process works out at a little higher cost per print but, apart from the cost of the Printmaker, it is very much simpler and more time saving, so the cost is likely to come down in due course. Likewise, we may well see machines and materials for larger sizes in the not too distant future.

Ektaflex PCT Activator
Available in 2,84 litre pack which processes approximately 75 pints 8" x 10" (20.3 x 25.4 cm). It is effective in temperatures from 18°C to 26.5°C (65°F to 80°F). Its active life in the dish is about 72 hours, but if returned to the container and properly sealed it will last up to 12 months.

Ektaflex PCT Negative Film
For making colour prints from colour negatives. Available in 10 and 25 sheet packs and 5" x 7" (12.7 x 17.8 cm) or 8" x 10" (20.3 x 25.7 cm) sizes. The 8" x 10" sheets are also available in packs of 100. Negative film should be refrigerated when not in use.

Ektaflex PCT Reversal Film
For making prints from transparencies. Available in the same sizes and packs as the negative film. It should also be refigerated.

Ektaflex PCT Paper
Available with F (smooth glossy) and N (smooth semi-matt) surfaces. Sizes are 5⅛" x 7¼" (13 x 18.4 cm) and 8⅛" x 10¼" (20.6 x 26 cm) and in 10 sheet and 25 sheet packs, plus 100 sheet packs for the larger sizes only. No refrigeration is required and they should be stored in the original package.

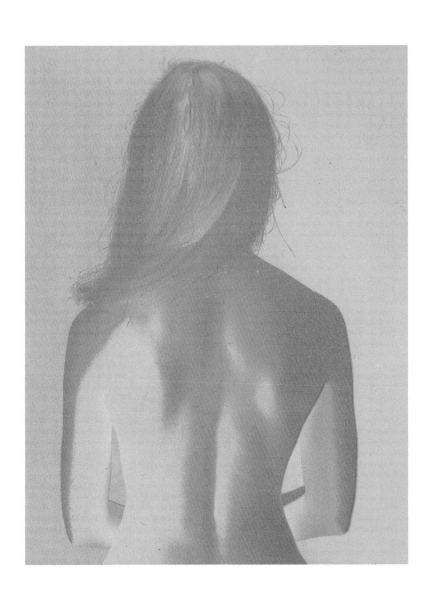

Acknowledgements

To produce a book such as this could only have been possible because of the many people who have given generously of their time and expertise. I wish to thank first and foremost Una Crawford; her limitless patience and good humour over many months whilst modelling for the photographs really made it all possible. I am particularly indebted to Lon Robinson, my editor; besides making many complex ideas seem so much easier to understand, his many years as a photographer working in advertising became invaluable when it came to solving the many technical problems that arose throughout the various stages of this book. Photographers Basil Barnes and Bay Hippisley also gave me valuable advice on photographic procedures and processes. Dr Bill Campbell, Colin Larkin, Jim Wire and Len Harrow encouraged me constantly and many first-class technicians came to my aid throughout: Frank Hillary at FEREF and the hardworking staff on the E-6 line at CETA and Paul Gates and Peter Sutherst at Kodak always seemed to be at the end of a telephone when required. Rob Willes at Process Supplies (London) Ltd. made sure I kept up to date with the latest materials and Bobby Warren seemed to be on call 24 hours a day to do the running around. My immediate family suffered my endless two-fingered typing and wife Ann came constantly to my aid by typing out and checking the rough drafts. Joy Fraser typed the final manuscript and George Wakefield kindly read it.

Finally, Harry Ricketts backed me all the way and as you can see diagram artist Colleen Payne and Art Director Grant Bradford have served me well.